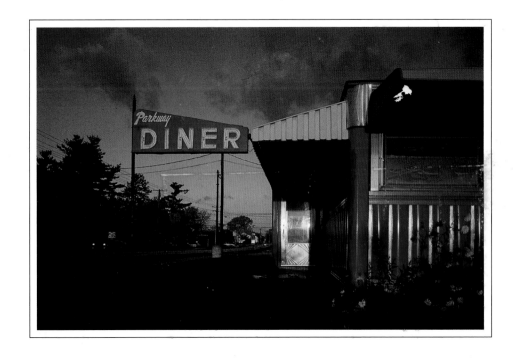

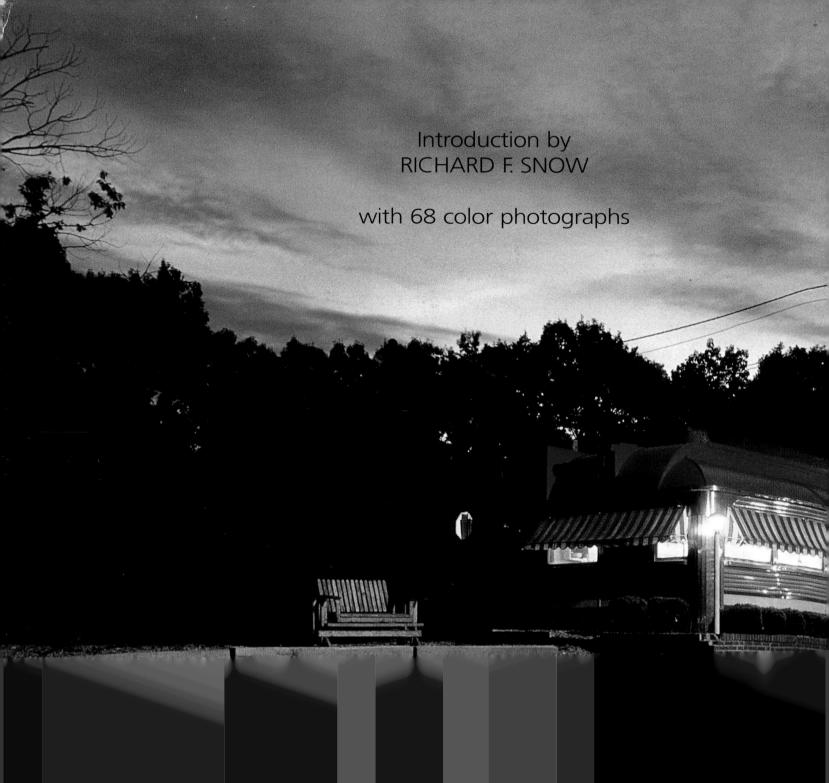

Introduction by
RICHARD F. SNOW

with 68 color photographs

GERD KITTEL

DINERS
PEOPLE AND PLACES

THAMES AND HUDSON

PAGE ONE
Parkway Diner, Burlington, Vt.

TITLE PAGE
Roadside Diner, Wall, N.J.

ACKNOWLEDGMENTS

I want to thank all the diners' guests and staff for their kindness and
hospitality; also for helping me to find my way with tips on "where
to go and have a look". I enjoyed reading and learned a lot about
the subject from the books by Richard J. S. Gutman and Elliott
Kaufman (*American Diner*, New York 1979), Donald Kaplan and
Alan Bellink (*Classic Diners*, New York 1980) and John Baeder
(*Diners*, New York 1978).
I am indebted to the firm of Deutsche Lufthansa A.G., and also
want to express my gratitude to Wolfgang Keller, Stanley Baron,
and the Stevens family.
GERD KITTEL

Photographs © 1990, 1998 Gerd Kittel
Text © 1990 Thames and Hudson Ltd, London

First published in the United States of America in paperback in 1990 by
Thames and Hudson Inc., 500 Fifth Avenue, New York, New York 10110

Revised edition 1998

Library of Congress Catalog Card Number 98-60457
ISBN 0-500-28081-9

Printed and bound in Singapore

AQUARTER CENTURY AGO in Portsmouth, New Hampshire, I climbed out of a windy September evening into the small, loud brightness of Gilley's lunch cart. There was barely room for me. All eleven stools were filled, and people pushed forward two deep behind, calling for hot dogs and fried egg sandwiches and coffee, passing up money and handing back brown paper bags. At the center of all this activity stood Gilley Gilbert, arms windmilling as the orders came in, working his little grill with an insolent calm that made my fifteen-year-old soul despair of ever being able to do *anything* so well. "Hey, Gilley," someone called from the doorway, "How's it going?"

"Aw," he replied, turning four hamburgers with one smooth roll of his right hand and setting up two plates of franks and beans with his left, "It's kinda quiet tonight."

This display of professionalism added to the sense I'd had since I spotted Gilley's that I was in the presence of something rather significant. And I was right. The stubby, barrel-roofed restaurant had wheels; Gilley drove it to Market Square at dusk, took it home at dawn; and in so doing he was among the last to be practicing a ninety-year-old ritual. Watching Gilley at his hectic post, I had gotten close to the origins of a sturdy and appealing tradition, one of the anchors of that great, billowing, amorphous fabric that is the American civilization. I was in a diner.

It didn't look like the ones I knew; those were long, low, solidly moored in concrete, striped with gleaming horizontal strata of stainless steel and porcelain. But somehow Gilley's felt the same. The sense of comfort and cheer that any good diner radiates is an amalgam of the actualities of the diner itself—the blunt facets of the salt and pepper shakers, the menus above the grill with their square white capital letters, the steam rising from the coffee urn, the clunk of cheap, solid china being slapped down on formica—and of memory. The melancholy, luminous and utterly precise photographs by Gerd Kittel that make up this book are, of course, about the actualities. You'll supply the memories.

But whether the diners of your youth were in Boston or Spokane or Boise, their progenitor was born in Providence, Rhode Island, in 1872, on the night Walter Scott first rolled into Westminster Street with a wagonful of five-cent sandwiches and a few thirty-cent platters of sliced chicken for the "dude trade." Scotty, whose only previous experience as a restaurateur had been selling pies from a basket, did well from the start. Working from dusk to dawn, he divided his time between handing out sandwiches and discouraging dead-beats. ("One of the Fox Point roughs tried to beat me out of 10 cents. I took his hat and he took a shot at me with his fist. We

5

clinched and rolled to the ground. I fell on top and pounded his head on the pavement until he cried enough.") He made a good living for nearly half a century.

In *American Diner*, their definitive book on the subject, Richard J. S. Gutman and Elliott Kaufman reproduce a picture of Scotty that ran in the Providence *Journal* when he finally retired in 1917 at the age of seventy-six. It shows a shaggy old scrapper upon whose neck some prig in the newspaper's photographic department has painted a ridiculous cravat. Scotty looks rather grim in the photo, and in fact he may have been; he didn't want to retire. "If some of the early patrons were tough customers," he said, "few of them wanted the earth for every nickel they spent . . . I don't know who invented the slice of onion with the fried egg. I know I didn't. With eggs and everything else high, there wasn't much profit in a sandwich at five cents, especially if you added the piece of onion . . . I'd probably be in business still if things weren't so high."

Scotty's success had swamped him. By the time he stepped down he had more than fifty rivals in Providence alone, and there were lunch wagons on the streets of every American city.

It's a peculiar name, "lunch wagon," since lunch was the one meal the horse-drawn carts never served. They came out at dusk and went home at dawn; before long, people were calling them "night owls." Scotty had started with an ordinary express wagon, and even when he prospered enough to have a snappy lunch cart made to order, it took the form of a sort of peripatetic store rather than a restaurant. Scotty was the only person who could go inside; the customers ate on the curb.

A Worcester, Massachusetts, bartender named Sam Jones changed that. Walking home one dismal evening in 1884 Jones noticed a crowd of people huddled around a lunch wagon eating sandwiches in the rain. Inspiration came immediately, capital more slowly. It took Jones three years to get out on the street with a lunch cart equipped with stools, a counter, a complete kitchen, and stained glass windows aglow with images of sandwiches and coffee cups.

Once launched, however, Jones's wagon caught on instantly. "Into . . . dull-streeted communities," the *New York Times* wrote years later, "came the lunch wagon, its cheery light shining like a hospitable deed in a chilly world . . ." There were fortunes to be made in this new business, and one of the first went to Thomas H. Buckley of Worcester (the town that was to diners what Florence was to the Renaissance). Buckley scattered 275 lunch wagons around the country before he burned himself out and died at thirty-five. His most celebrated creation was a line of "White House Cafes," sixteen feet long, seven or eight wide and ten high, some of

them with murals on their sides and garnet windows etched with such ennobling visions as the Goddess of Flowers or President Cleveland.

As the century drew to a close, these "perfect little palaces," as one contemporary hailed them, ran into some raffish competition. The street railway companies were beginning to electrify, and their discarded horsecars could be quickly and cheaply turned into serviceable eateries. As the newcomers proliferated, and the first generation of lunch wagons began to show their age, night owls started to draw fire from citizens' groups. Communities added teeth to the local ordinances that kept the unsightly wagons off the streets between dawn and dusk. The beleaguered owners found a simple way to get around the law: rent a small patch of ground and put the wagon on it permanently—that way it ceased to be a night owl and became a restaurant, immune to the rulings levelled against its mobile counterparts. All across the country lunch wagons came down off their wheels.

The dodge worked, but the proliferation of cheap, often seedy lunchrooms gave diners a bad reputation. This was a problem that interested Patrick Tierney, a New Rochelle, New York, manufacturer who is still remembered in the business as the man who reclaimed the reputation of the diner by "bringing the toilet inside." In 1905 "Pop" Tierney started selling solidly built miniature restaurants, thirty feet long and ten and a half feet wide (the maximum permitted for railway shipment). Tierney's cars were true diners, lavish creatures with tile floors and stretches of shining metal beginning to appear behind the counter. By the time Scotty gave up his inaugural lunch wagon in 1917, Tierney's shop was turning out a diner a day. Others entered the business—a Bayonne, New Jersey, man named Jerry O'Mahony began putting together diners as good as Tierney's (and, according to O'Mahony, the best in the world)—and throughout the 1920s they popped up in small towns across the country, serving motorists as the depot restaurant had served their parents. Tierney and his competitors did their work well; by the end of the decade diners were universally regarded as safe, cheap places to eat—a reputation that did them no harm during the 1930s. In those straitened years, the manufacturers promoted their products as a "depression-proof business" that could earn the prudent operator $12,000 a year.

Once the diners had established a solid foundation of respectability, their looks started changing. The barrel roof that had been there from the start gave way to clerestories borrowed from railroad coaches, while stainless steel and enamel began to replace the wooden sides. And with industrial designers imparting aerodynamic qualities to things like pencil sharpeners, the diner's lean profile and vague associations with transportation made it an inevitable candidate for streamlining. About

1940 an advertisement put out by a Merrimac, Massachusetts, company exulted: "Just as the magic of streamlining has drawn thousands upon thousands of new customers to the streamliners of rail and air; just so the streamlined eye appeal of *Sterling Diners* never fails . . . The sleek lines of Sterling Streamliners . . . practically shout. 'This MUST be a good place to eat.'" The racy diesel snout of the Sterlings— that's one on page 23—helped contribute to the apparently indestructible myth that most diners of the era are discarded railway equipment.

The Sterlings flourished in the great age of the diner, the years just before and after World War II when it took on the form it would keep well into the 1950s: lots of tile and formica, stainless steel backbars pleated into art moderne rays, and perhaps a clock collared with a buzzing circle of neon. There were booths by now, of course, and blenders that bore the name "Osterizer" on a metal plaque substantial as the builder's plate on a triple-expansion steam engine. The countermen seemed to divide themselves into two types: wiry veterans of the Depression's seventy-hour, twelve-dollar weeks, and kids in their late teens, very brisk and peppy in their white jackets and caps. This latter group seemed the more likely to throw around diner talk: "Adam and Eve on a raft, wreck 'em [two scrambled eggs on toast] and a grease spot [hamburger]." This banter never rang quite true to me, because it so often failed to fulfill the chief function of slang, which is economy. It is not really easier to say "nervous pudding" than "jello." The talk, rather, signalled the speaker's place in a fraternity. It was a happy assertion of his right to preside over all that clean, flashing metal.

This is the diner of my memory, the place where I first, at my father's urging, had that supreme (to a ten-year-old) delicacy, the breaded veal cutlet; where I marked, grainy-eyed and exhilarated at the end of a night-long party, my first morning as a high-school graduate; where I picked dispiritedly at my home fries after driving a friend to the gates of the army, gloomily amazed that my classmates and I had wandered so far into the foothills of adulthood.

My particular diner, a trim, medium-sized stainless steel model that stood high on a wedge of grass in the New York suburb of Eastchester, was a perfect representative of the classic diner at the postwar zenith of its development. It seemed to me so splendidly evolved, so happily suited to its function, that it no more needed improvement than did the opposed thumb. But of course well enough is rarely left alone, and even as I was becoming conscious in the mid-1960s of just what was so good about diners like this one, they were beginning to disappear. Many, their business withering as the fast food chains burgeoned, simply were torn down. Others—and this

was sadder—were renovated with such dross as mansard roofs (a peculiar straw in the wind of the post-modern architecture that was on the way), shingling, and a hideous frosting of concrete mixed with gumdrop-colored pebbles. My own shining Eastchester paragon has, in recent years, been transformed into an inexpressibly dreary little brick cube. Then, too, there are curious mutations, born along the highways of New Jersey, that call themselves diners but in fact are gaudy Mediterranean fantasies full of plum-colored naugahyde and gold-veined mirrors. They even offer cocktails, which would have appeared about as often as a dance floor in one of Pop Tierney's operations. Their tie to the diner lies in a vestigial counter (*every* diner has a counter), but the cook has been moved far back into an invisible kitchen: no seething fry pots and fancy spatula work to divert the customer—just fat, tasseled menus that offer shishkabab and chicken kiev.

These effulgent places, and the fast food chains, have claimed many victims in recent years; the Napanoch on page 53 is one, the Apple Tree, standing in the garden of a Hanson, Massachusetts, auctioneer, is another. "A lot more diners will vanish," says Gerd Kittel. "Nobody seems to think about them as unique and worth preserving. This book is not meant to be representative in any way—no biggests and bests . . . It's a small photographic essay and part of a larger project on the American roadside culture and its protagonists."

But as Kittel's photographs most eloquently testify, the classic diners do have a way of enduring. There is something in our culture that cherishes them. Even in a tarted-up impostor like Manhattan's Empire (page 71), which has added self-conscious art-deco frills to its façade and grilled chicken breast with herb butter to its menu, a waiter once solemnly told a friend of mine that she couldn't have decaffeinated coffee because it was "against the spirit of the diner."

Or take Gilley's Lunch Cart. In 1974 Gilley Gilbert, after forty years of "kinda quiet" nights, decided it was time to call it quits. Portsmouth knew what it was losing; the town gave him a parade and a Caribbean cruise—but it also passed an ordinance to ensure that nobody else could drive a night owl into Market Square. The wagon was left to molder in a nearby parking lot. In time, a local taxi driver who shared the lot noticed that people kept coming up to the red-and-cream hulk and going away disappointed. The driver was an enterprising man, and before long the little, round-roofed cart was again serving up burgers and westerns and coffee and fries. Gilley's had come down off its wheels, just as its predecessors did to beat the laws seventy-five years before, and it was a true diner at last.

RICHARD F. SNOW

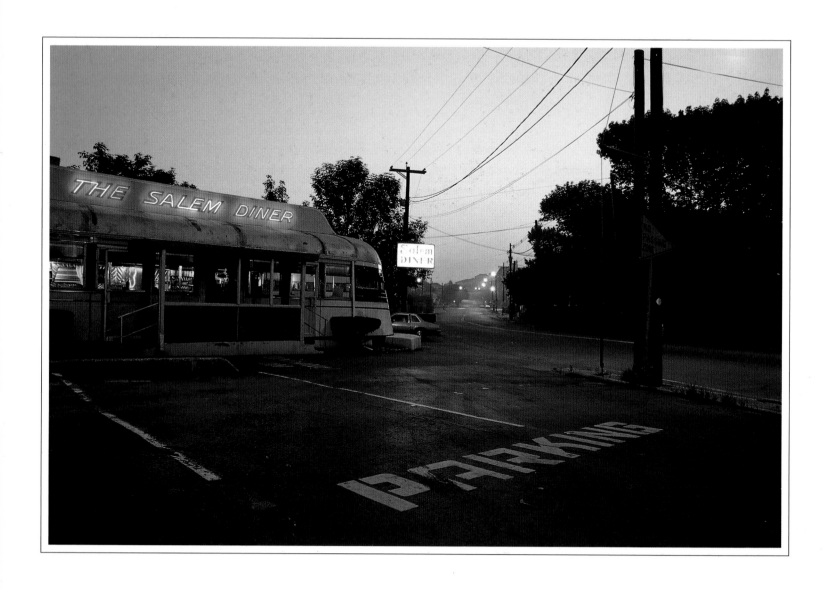

Salem Diner, Salem, Mass.

Charlotte's Diner, Ellenville, N.Y.

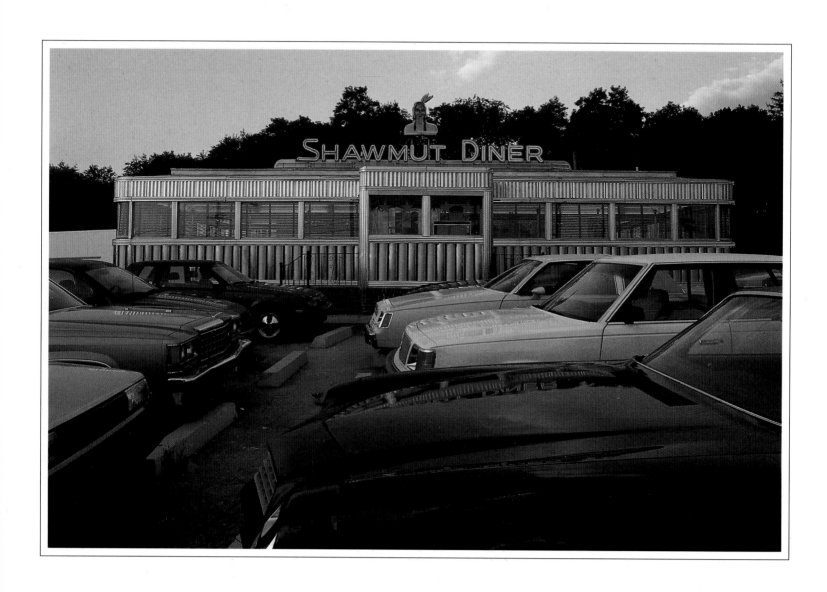

Shawmut Diner, New Bedford, Mass.

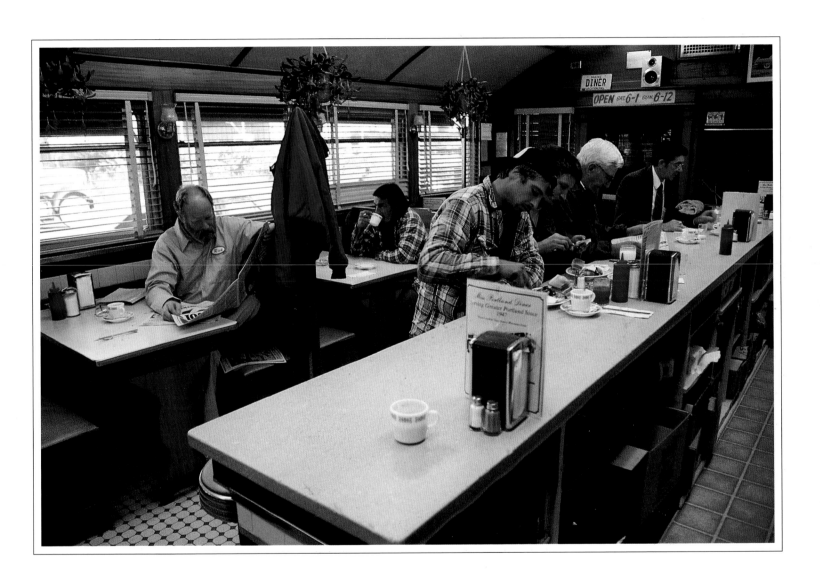

Miss Portland Diner, Portland, Me.

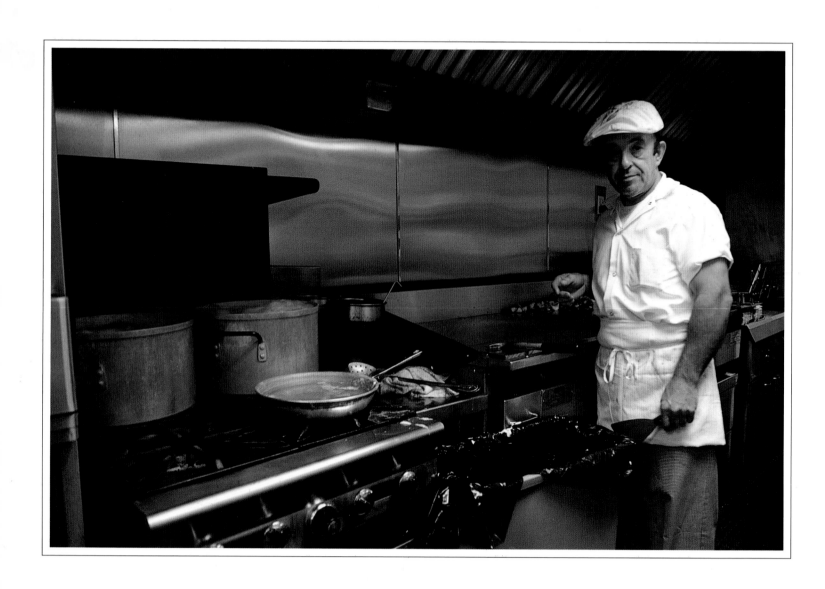

Miss Portland Diner, Portland, Me.

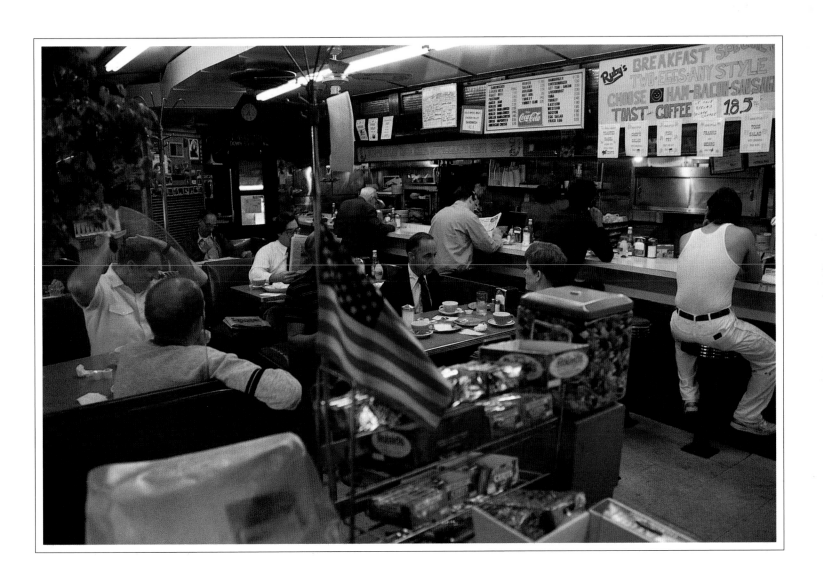

Ruby's Diner, Schenectady, N.Y.

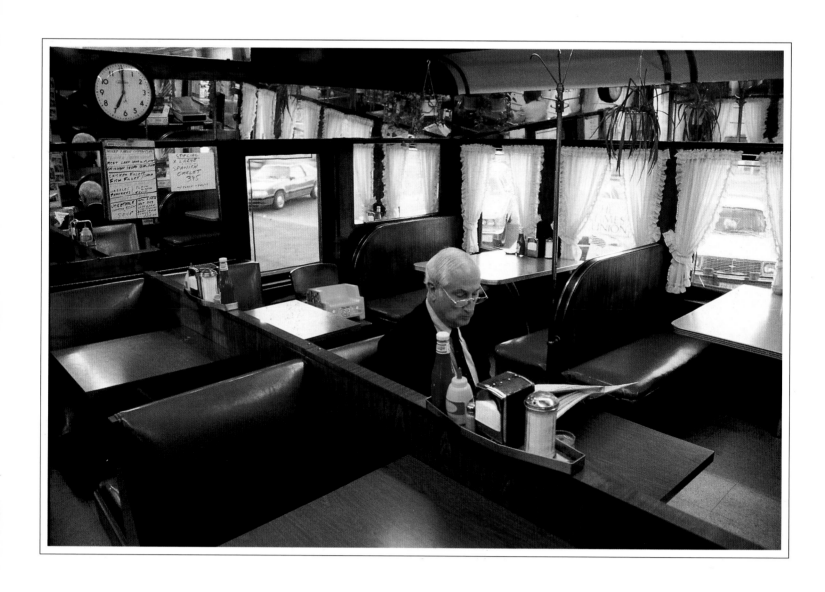

Ruby's Diner, Schenectady, N.Y.

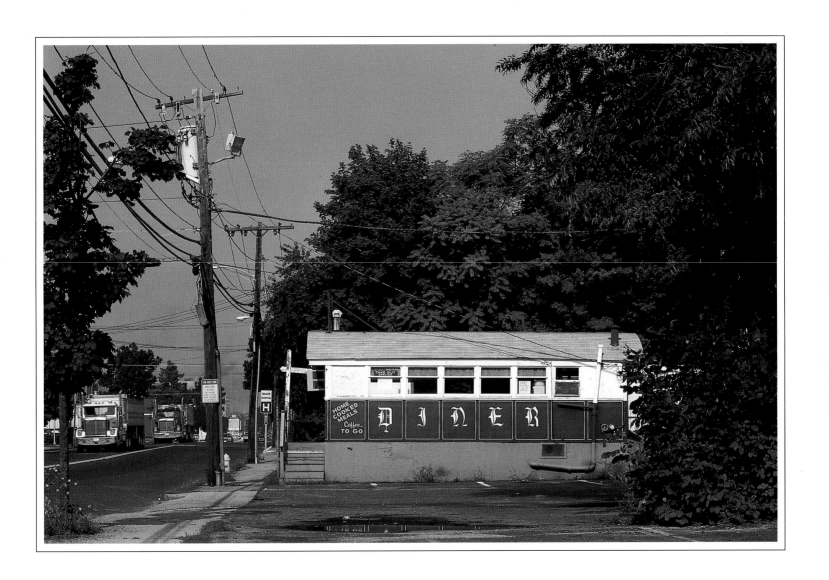

Viv's Diner, Malden, Mass.

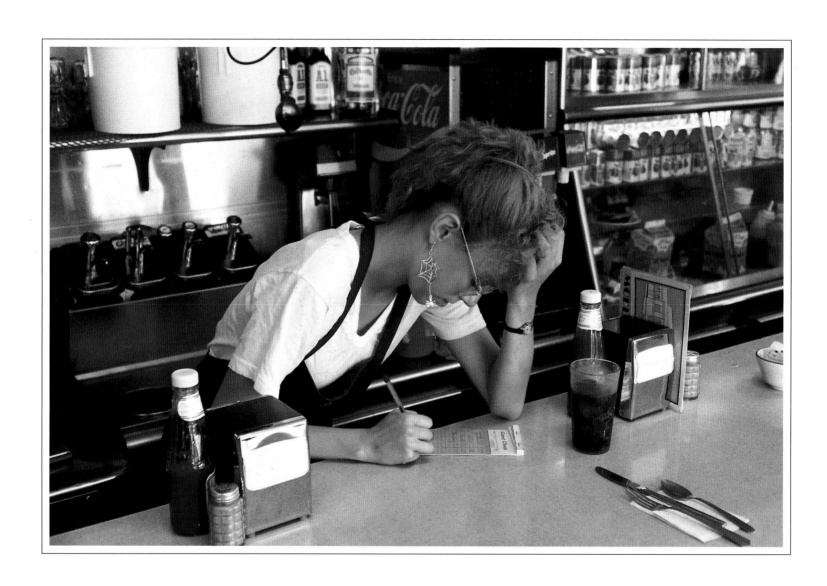

Modern Diner, Pawtucket, R.I.

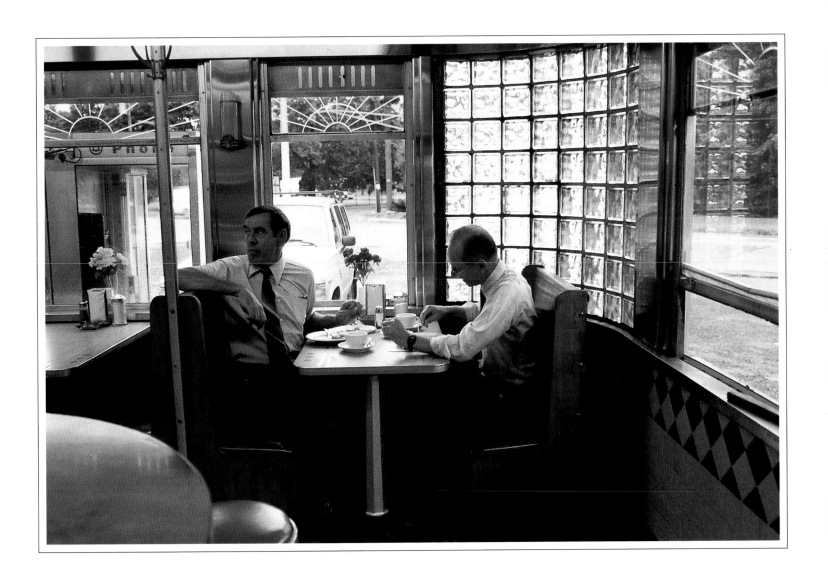

Teamster's Diner, Fairfield, N.J.

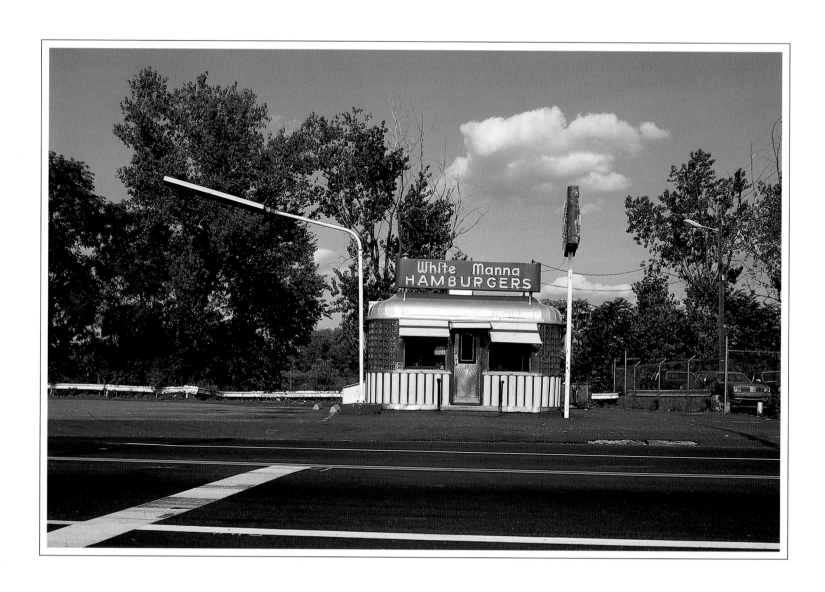

White Manna Hamburgers, Hackensack, N.J.

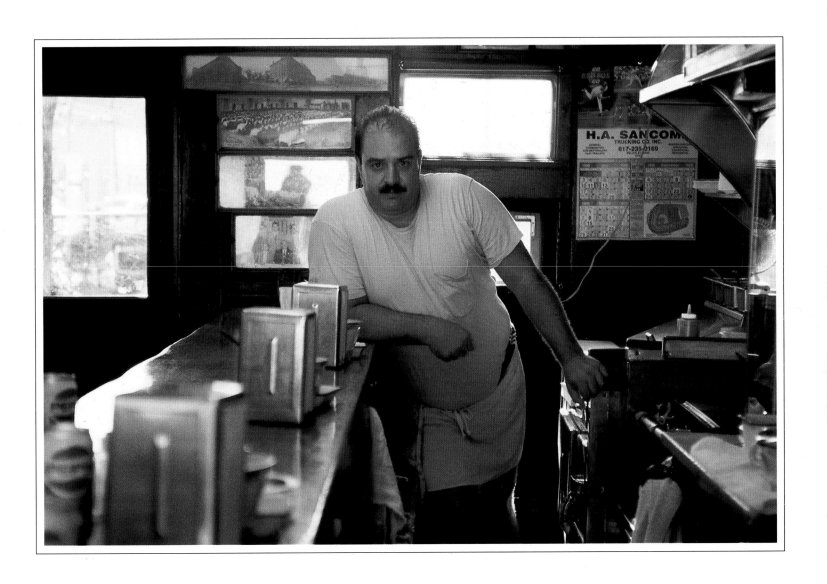

Casey's Diner, Natick, Mass.

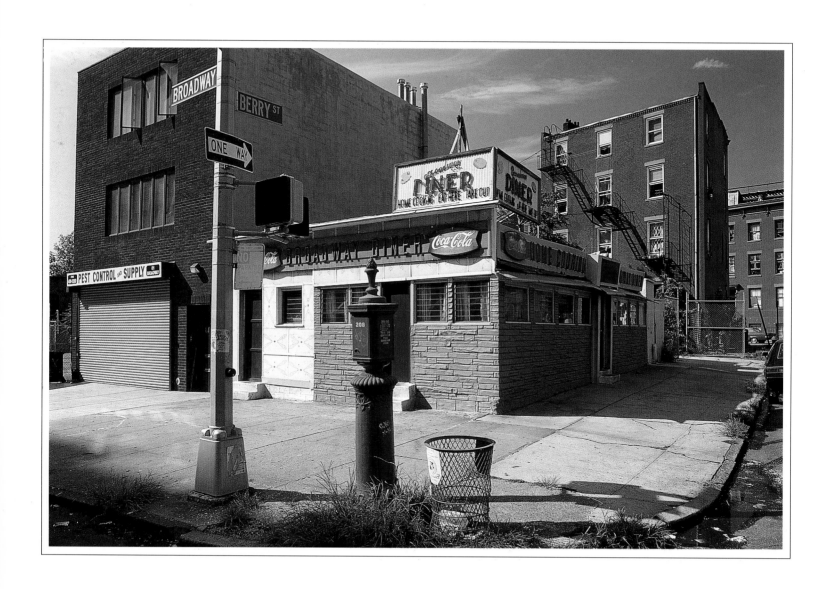

Broadway Diner, New York, N.Y.

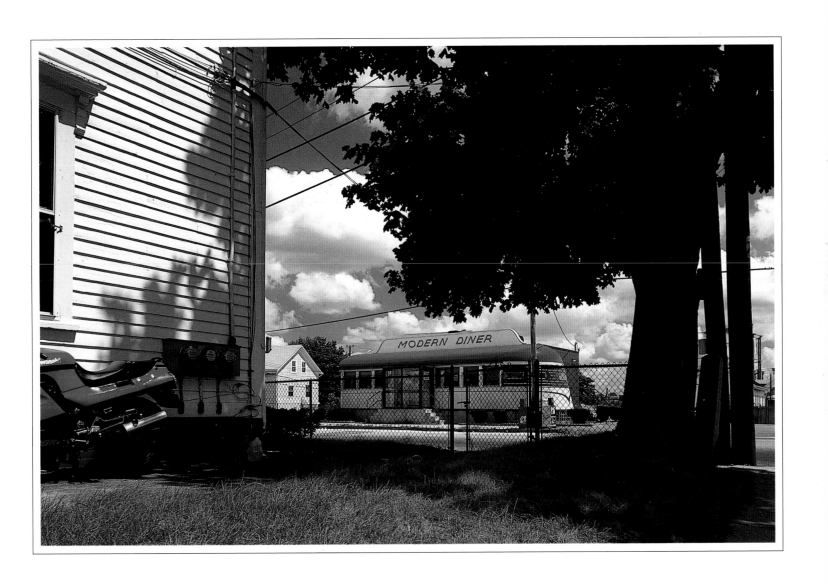

Modern Diner, Pawtucket, R.I.

Joann's Diner, Providence, R.I. ⟩

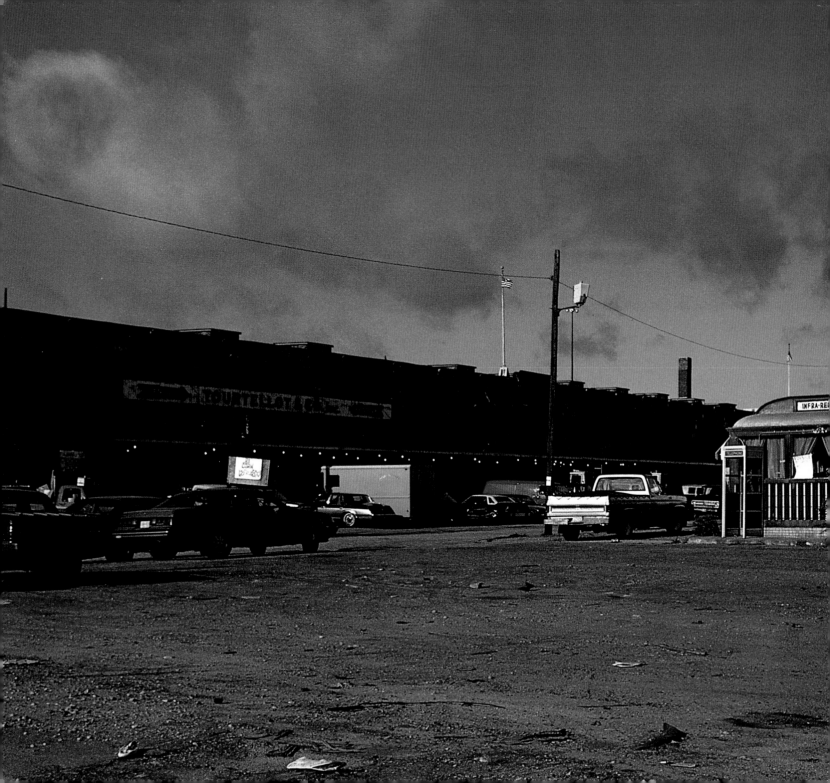

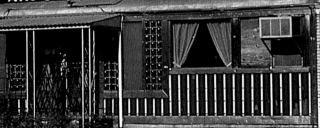

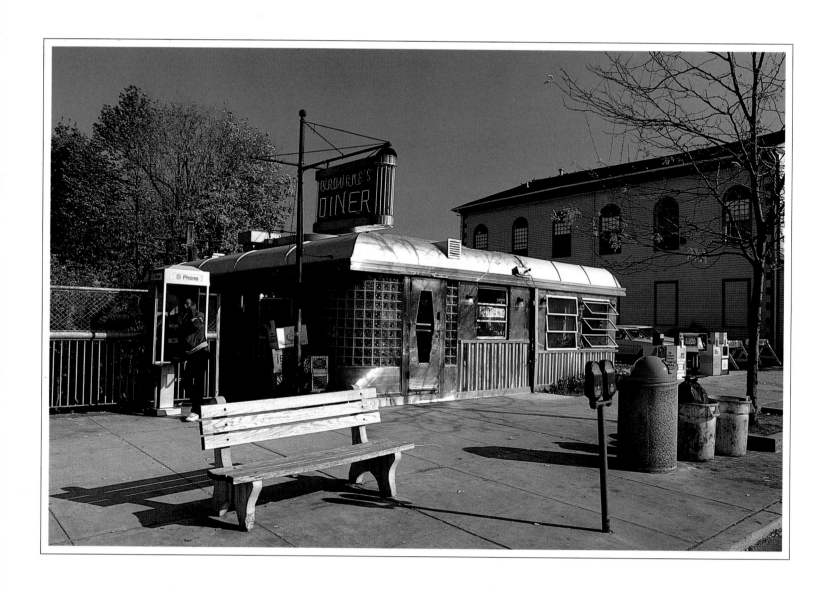

O'Rourke's Diner, Middletown, Conn.

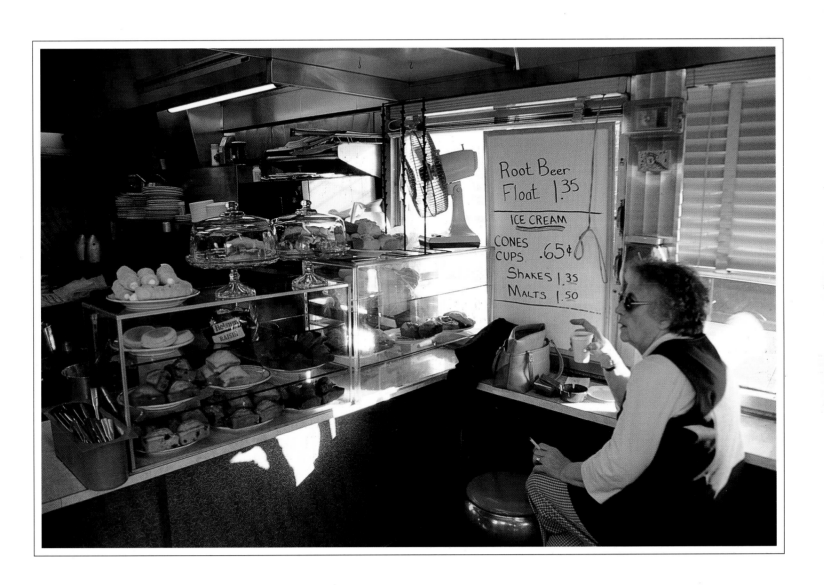

Nite Owl Diner, Fall River, Mass.

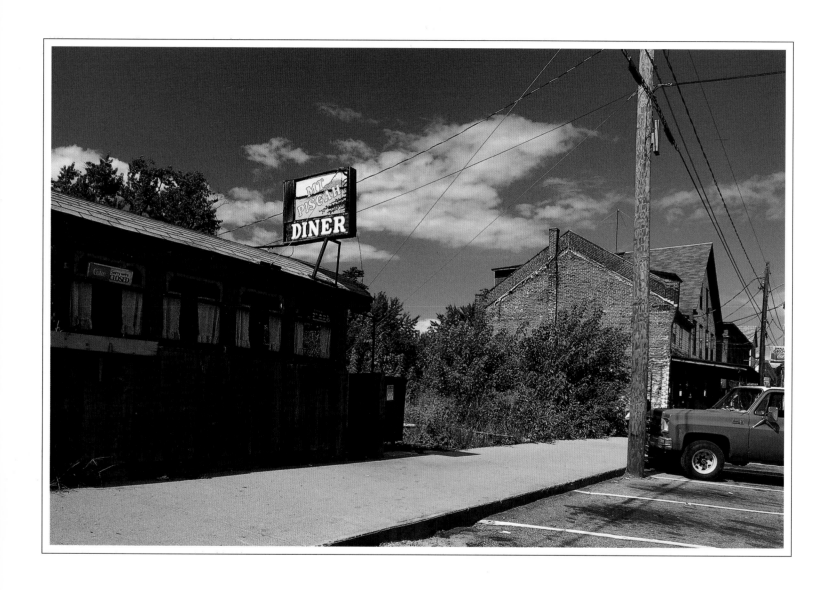

Mt. Pisgah Diner, Winchester, N.H.

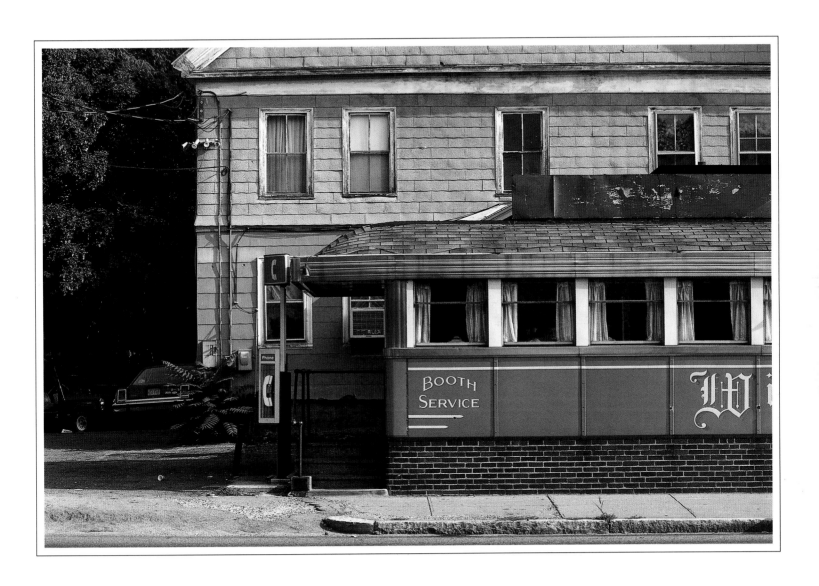

Wilson Diner, Waltham, Mass.

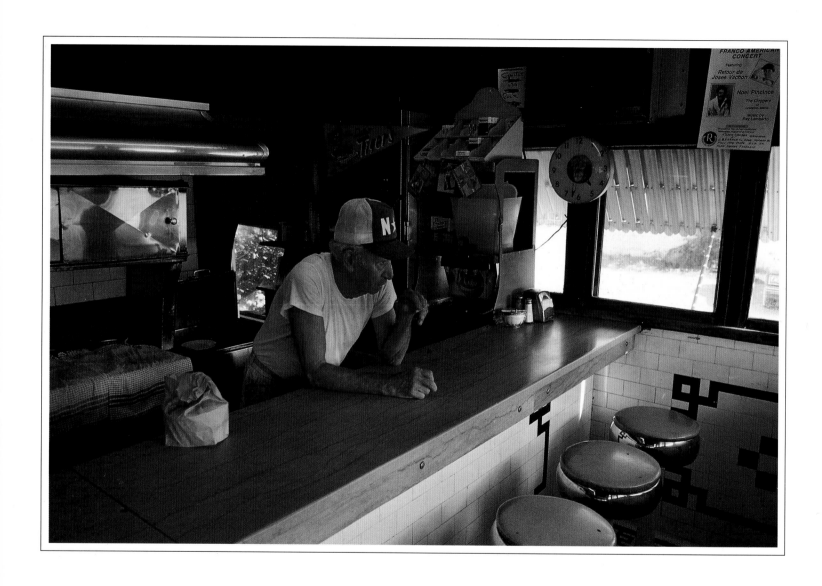

Champ's Diner, Woonsocket, R.I.

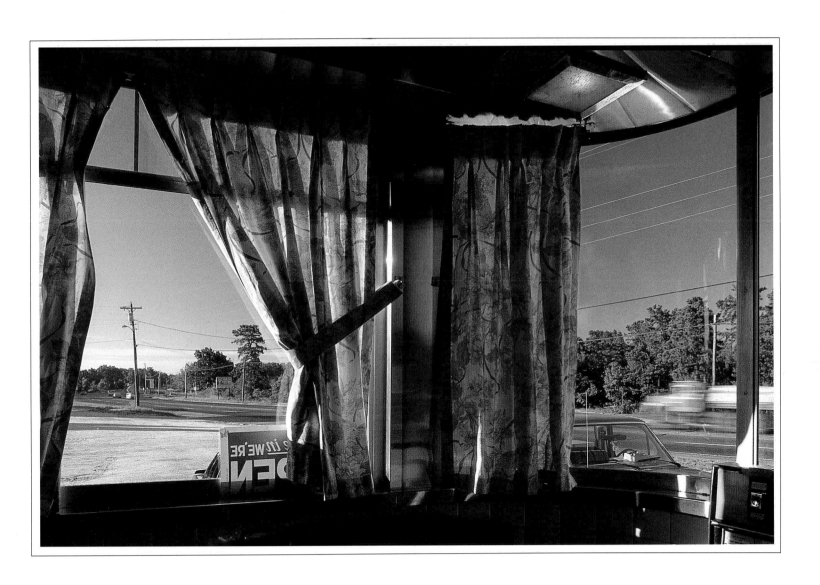

Triangle Diner, Folsom, N.J.

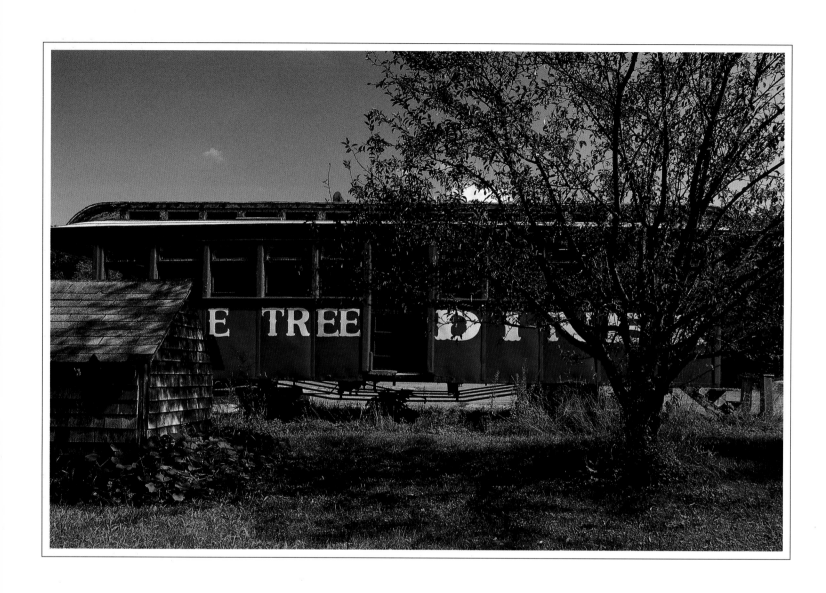

Apple Tree Diner, Hanson, Mass.

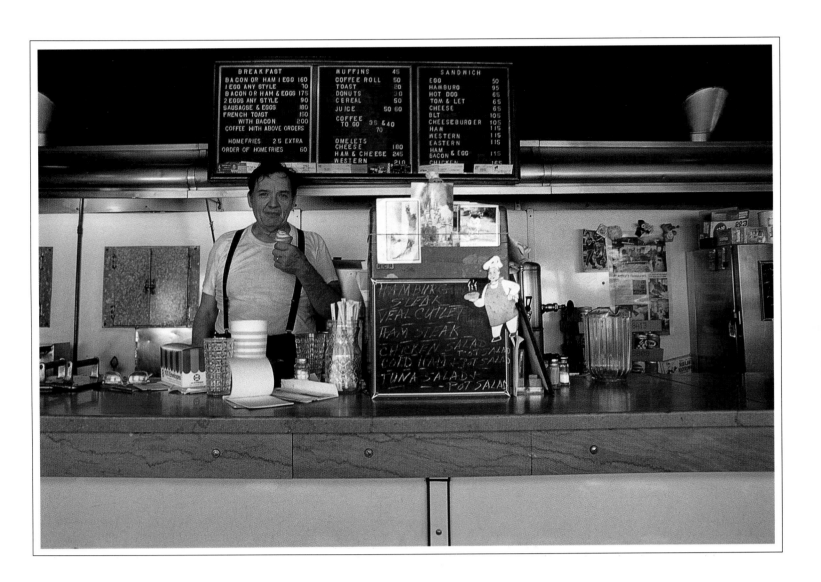

Arthur's Diner, Lowell, Mass.

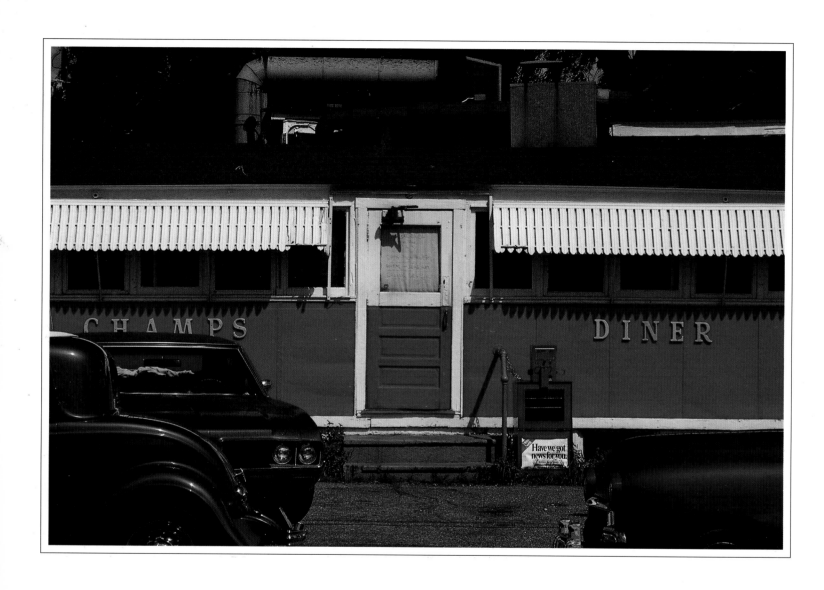

Champ's Diner, Woonsocket, R.I.

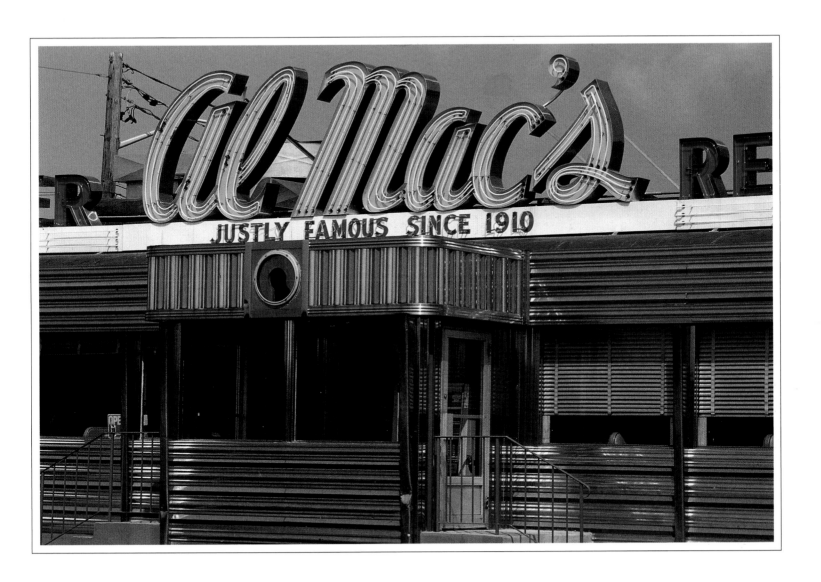

Al Mac's, Fall River, Mass.

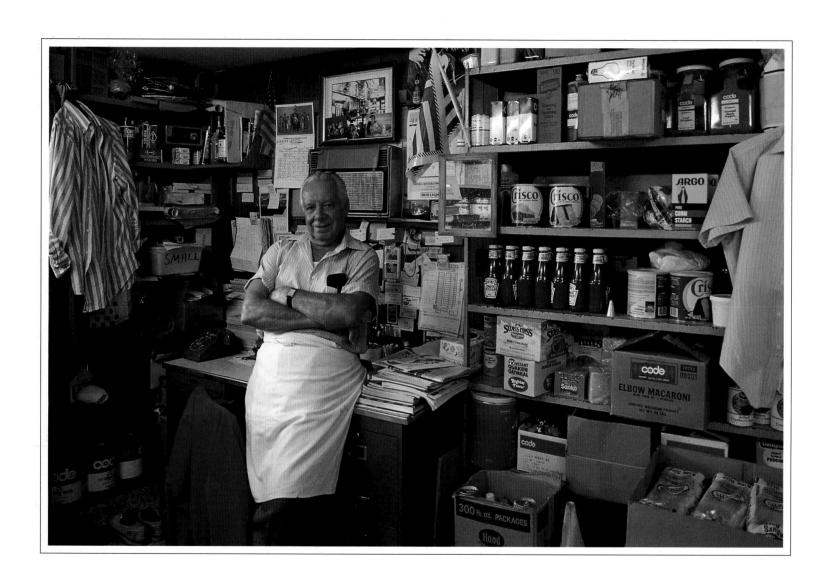

Parkway Diner, Burlington, Vt.

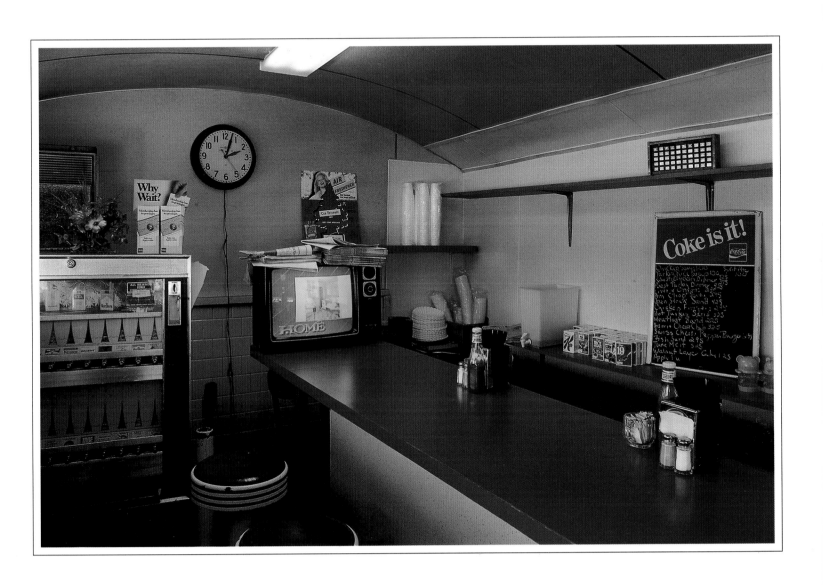

Ted's Diner, Milford, Mass.

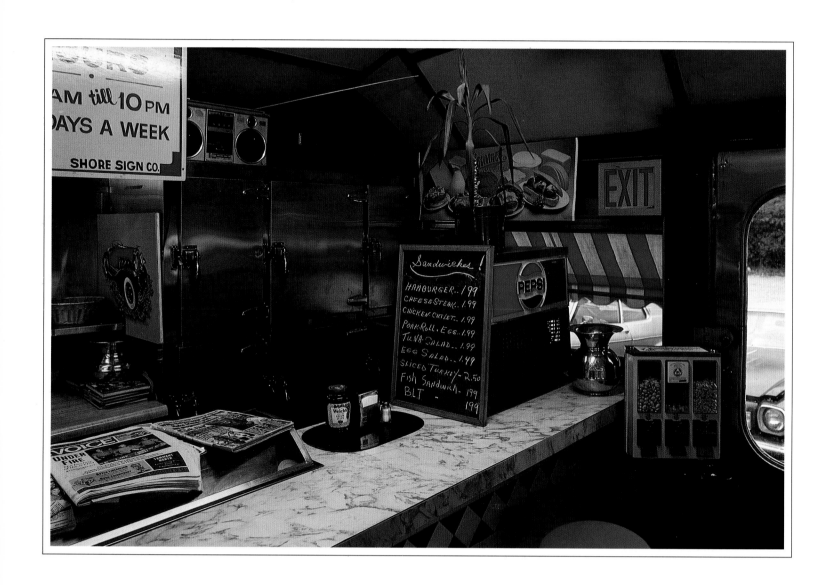

Roadside Diner, Wall, N.J.

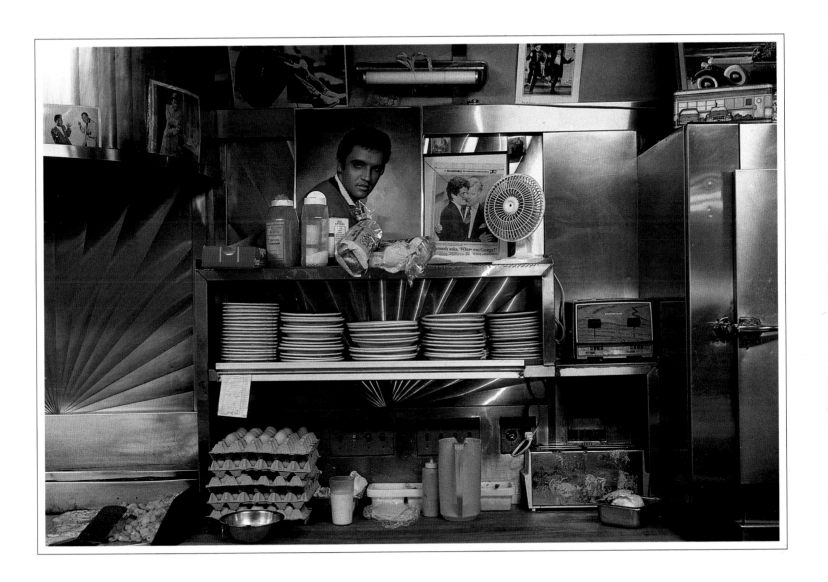

Arnold's Diner, Providence, R.I.

Fish Tale Diner, Salisbury, Mass. 〉

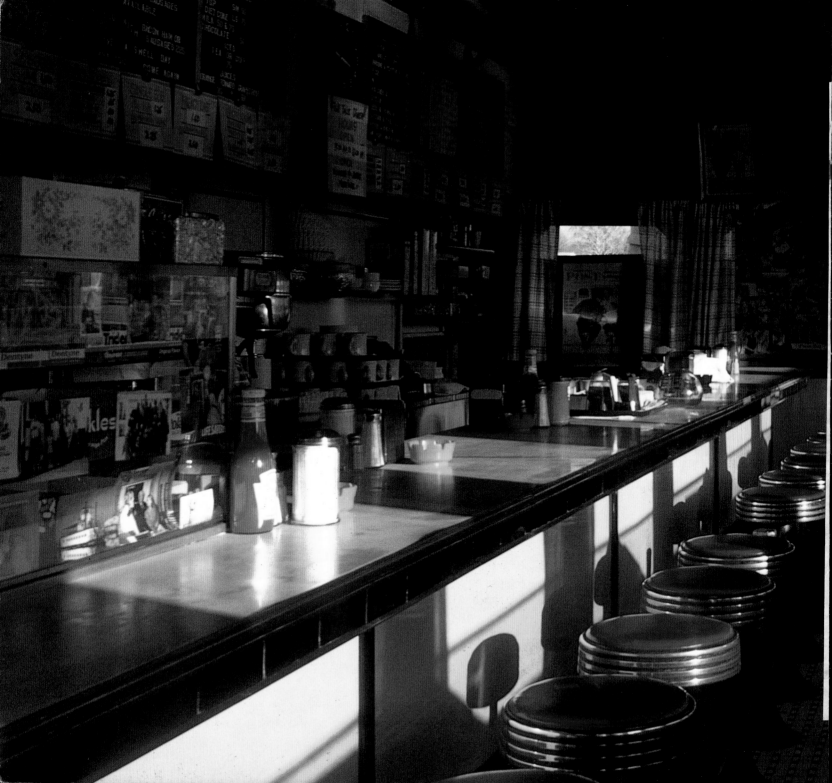

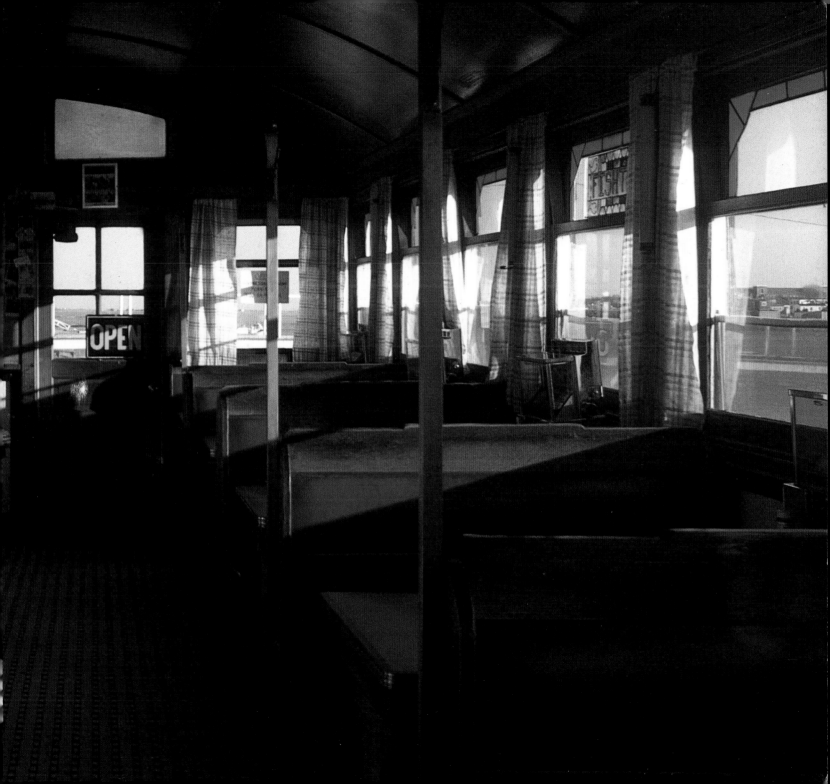

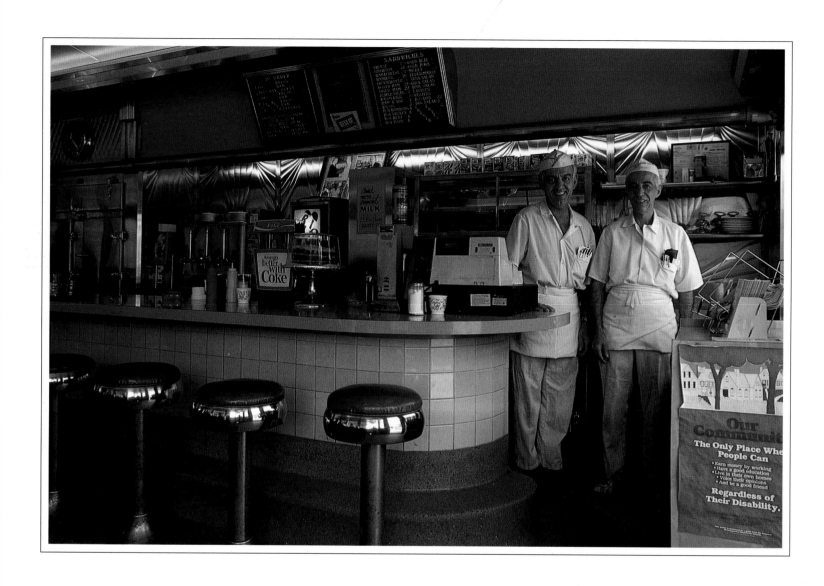

45 Oasis Diner, Burlington, Vt.

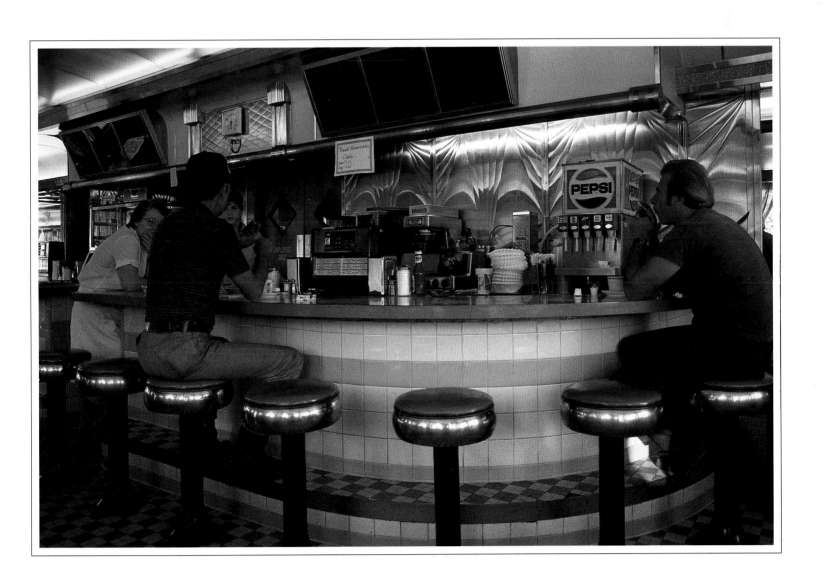

Triangle Diner, Folsom, N.J.

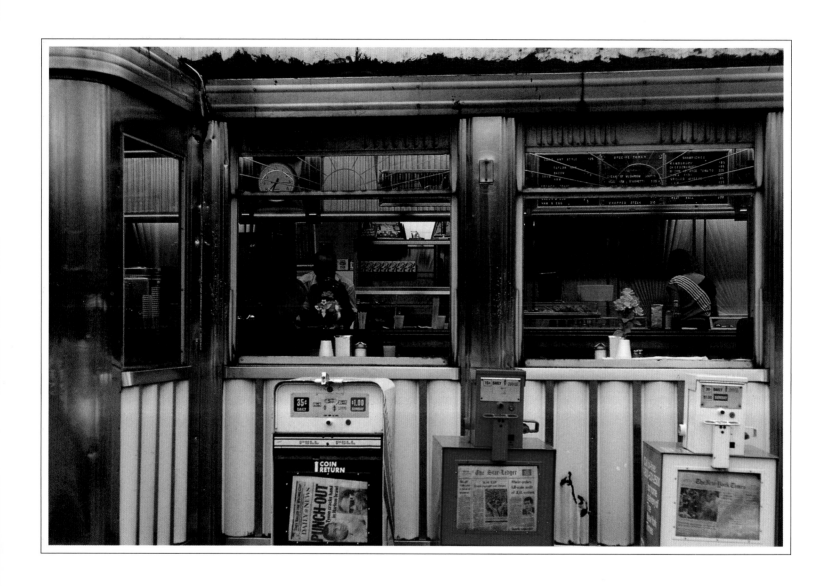

Teamster's Diner, Fairfield, N.J.

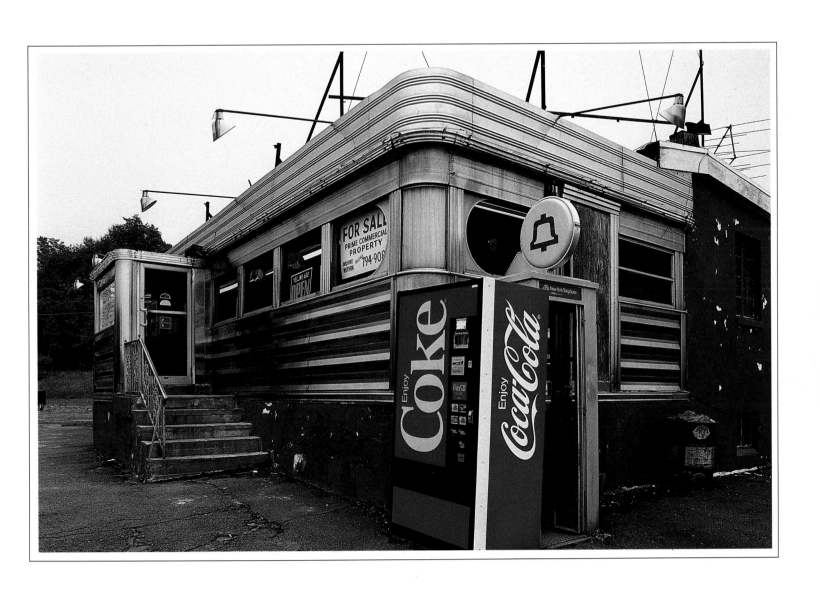

Pioneer Diner, Monticello, N.Y.

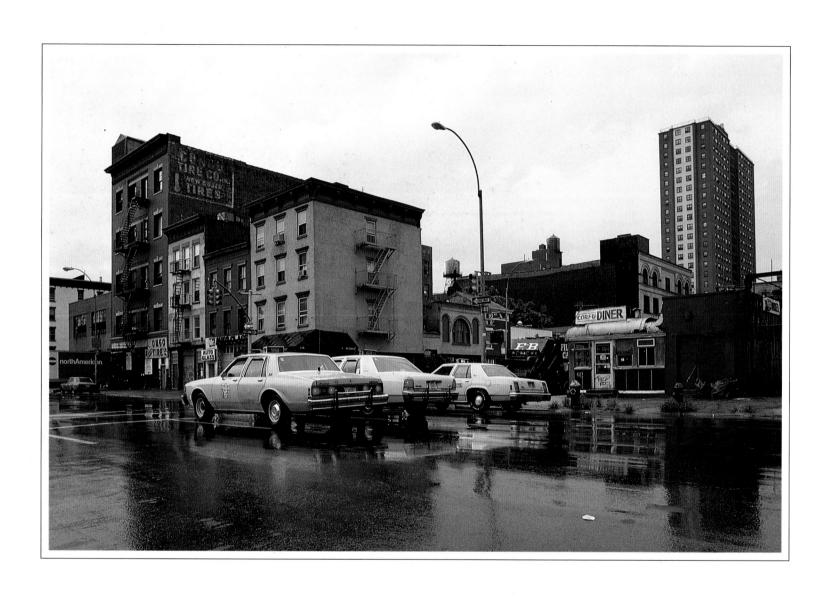

Corfu Diner, New York, N.Y.

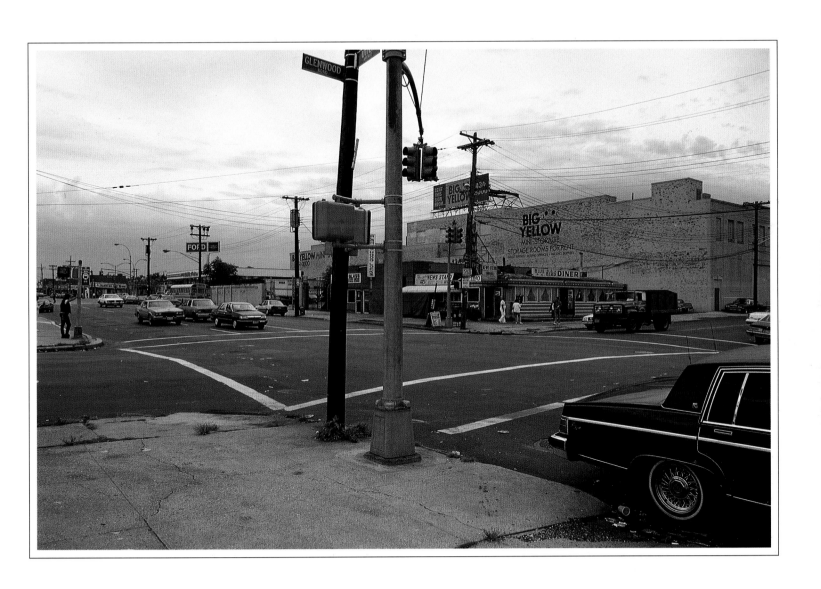

Blue Bird Diner, New York, N.Y.

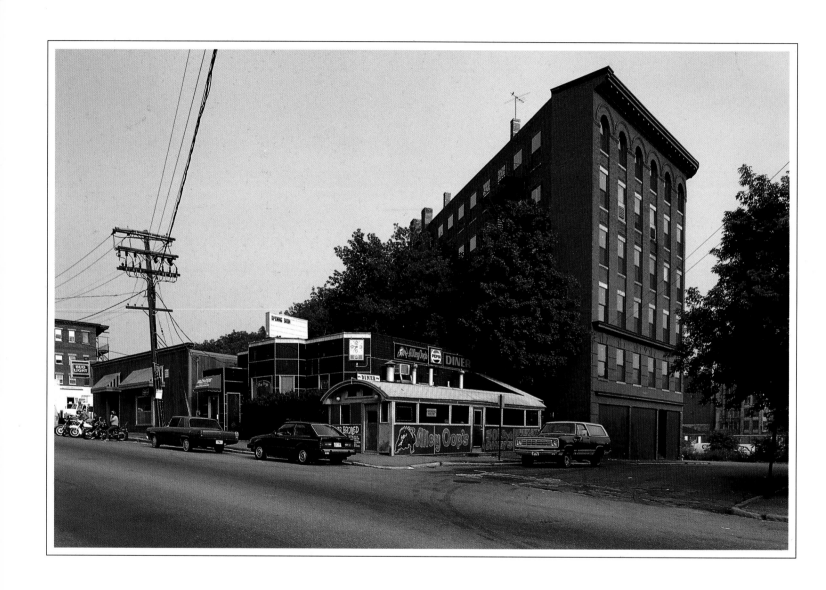

Alley Oop's Diner, Haverhill, Mass.

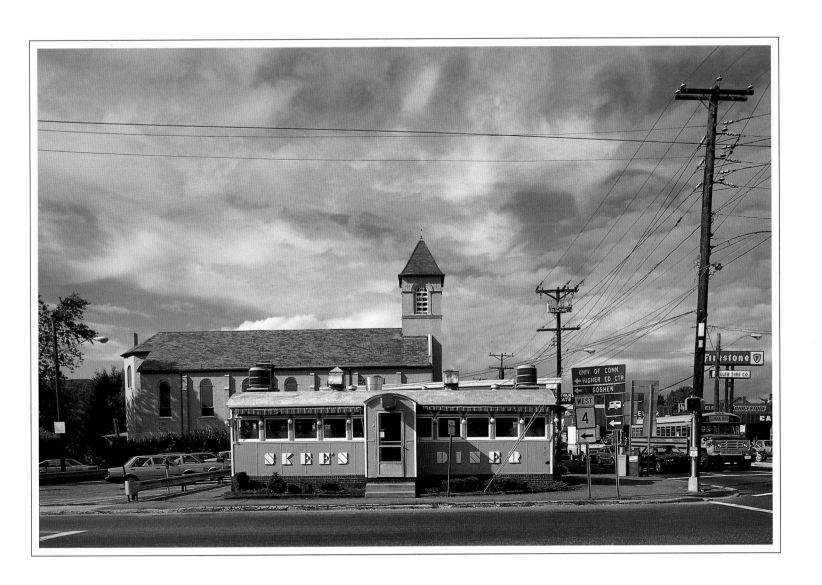

Skee's Diner, Torrington, Conn.

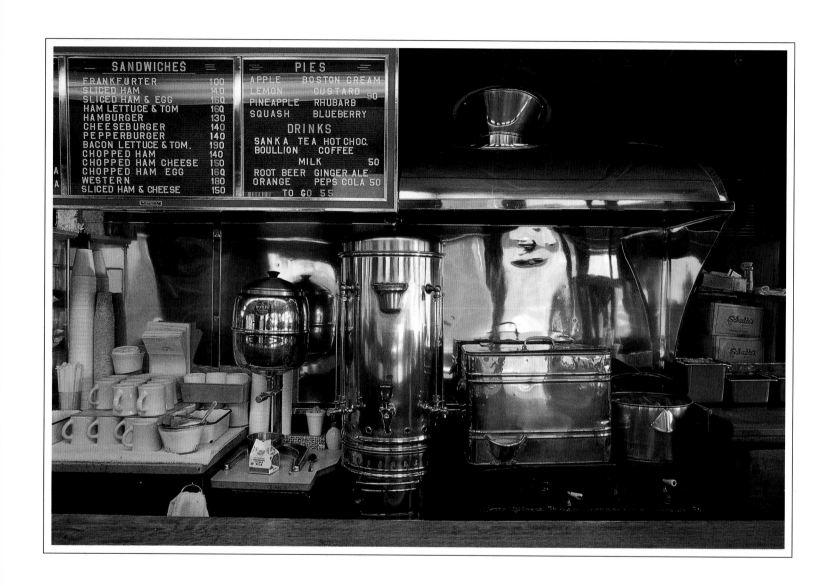

Casey's Diner, Natick, Mass.

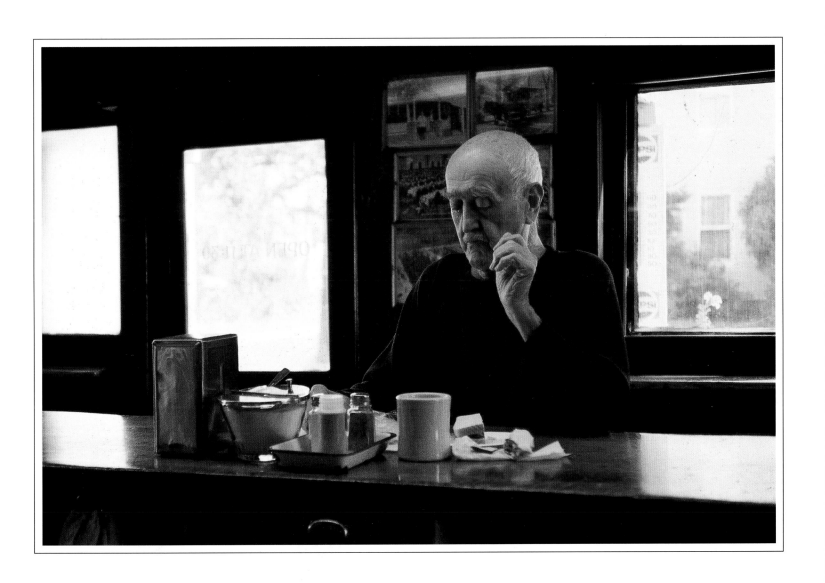

Casey's Diner, Natick, Mass.

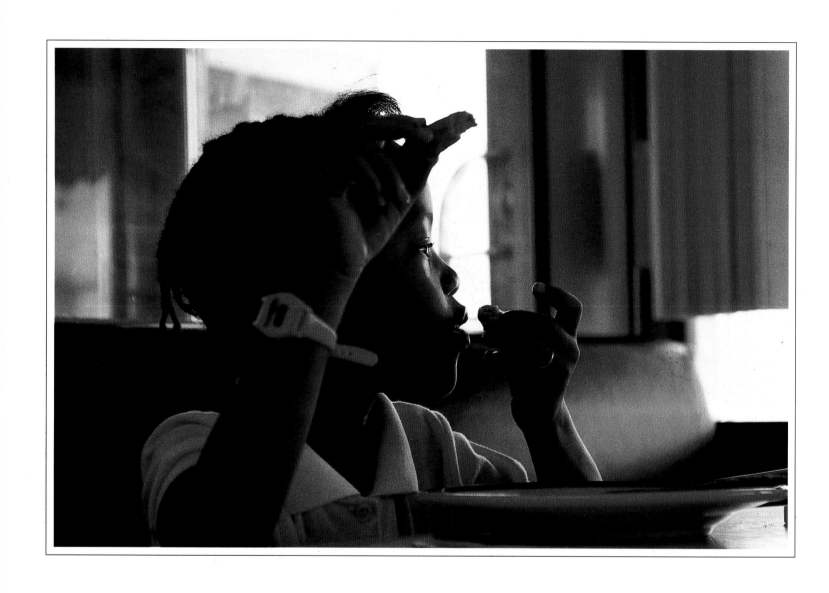

Angelo's Diner, Glassboro, N.J.

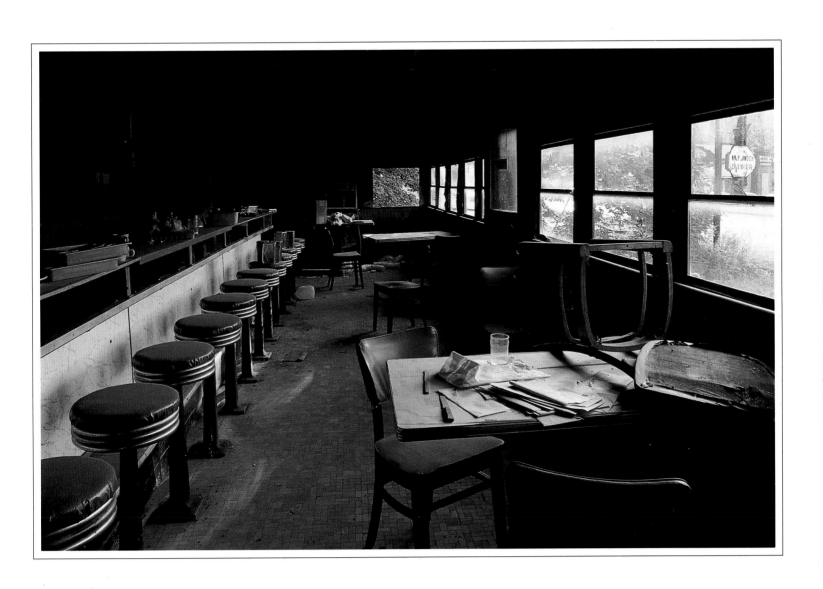

Napanoch Diner, Napanoch, N.Y.

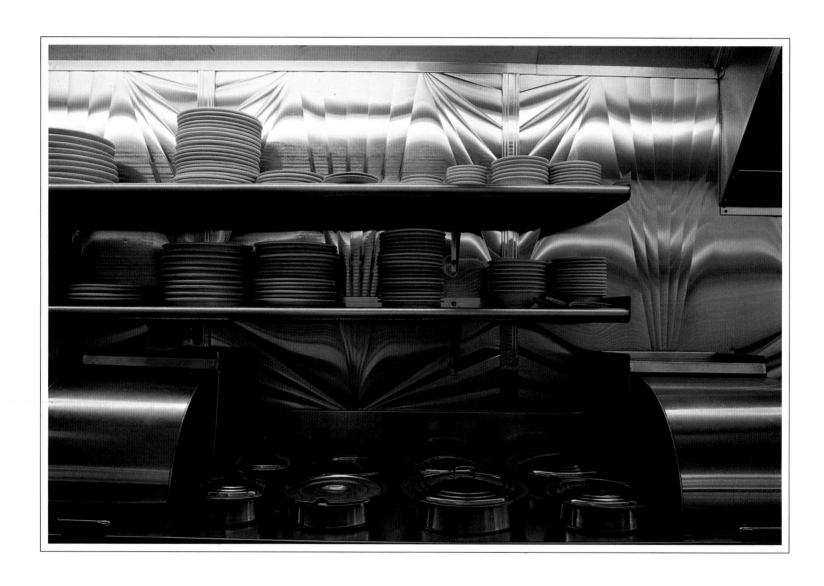

Oasis Diner, Burlington, Vt.

Parkway Diner, Burlington, Vt.

A1 Diner (Heald's), Gardiner, Me. ❭

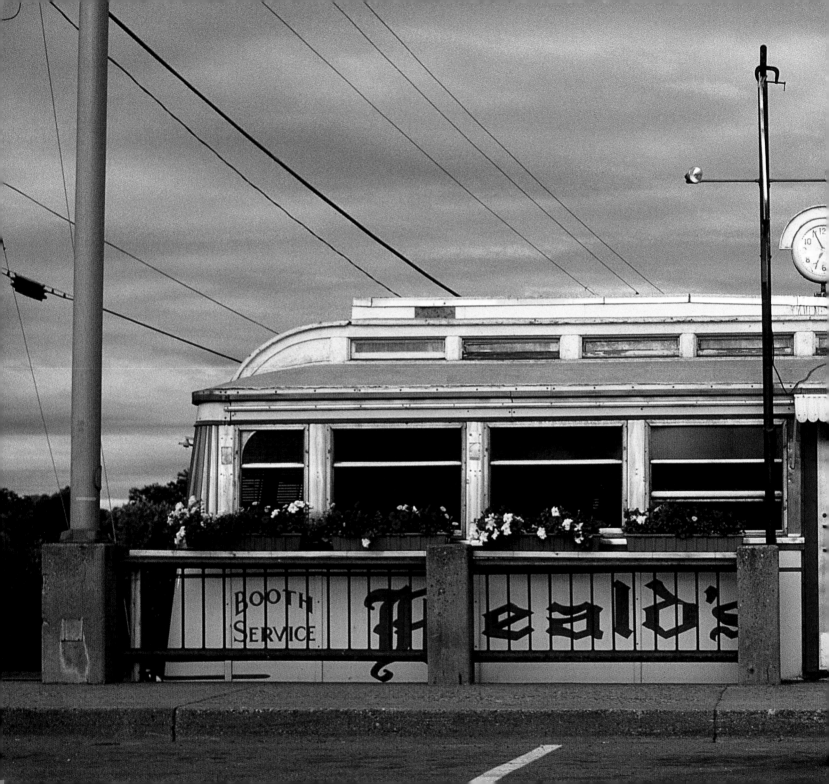

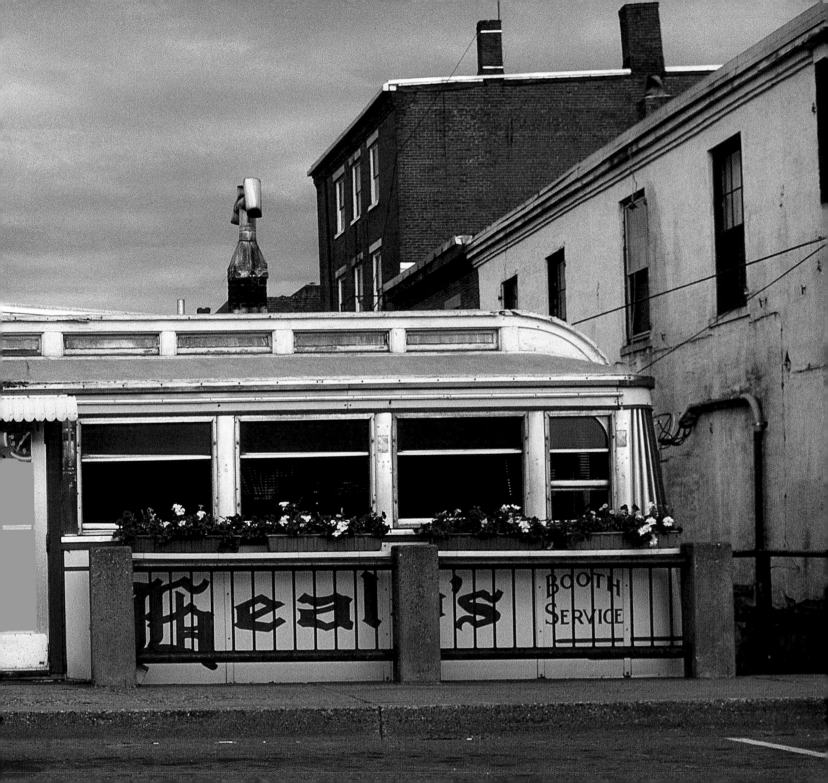

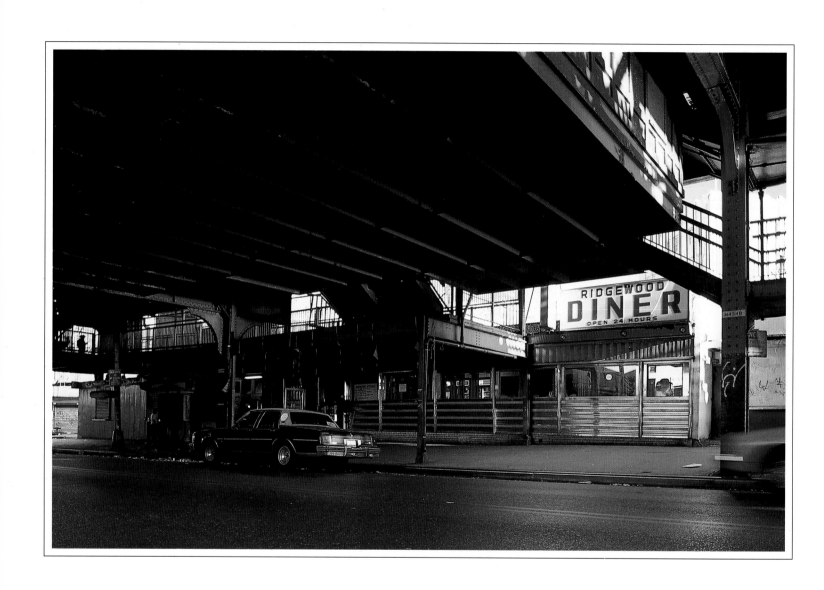

Ridgewood Diner, New York, N.Y.

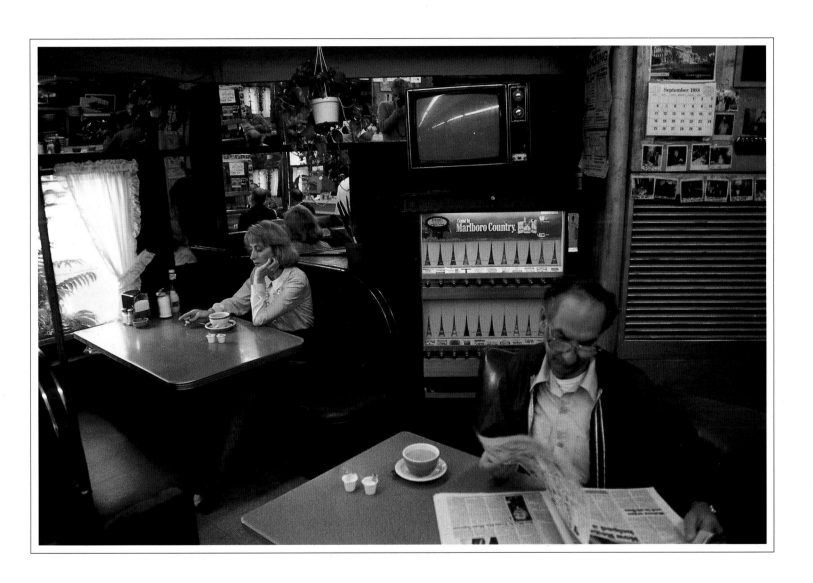

Ruby's Diner, Schenectady, N.Y.

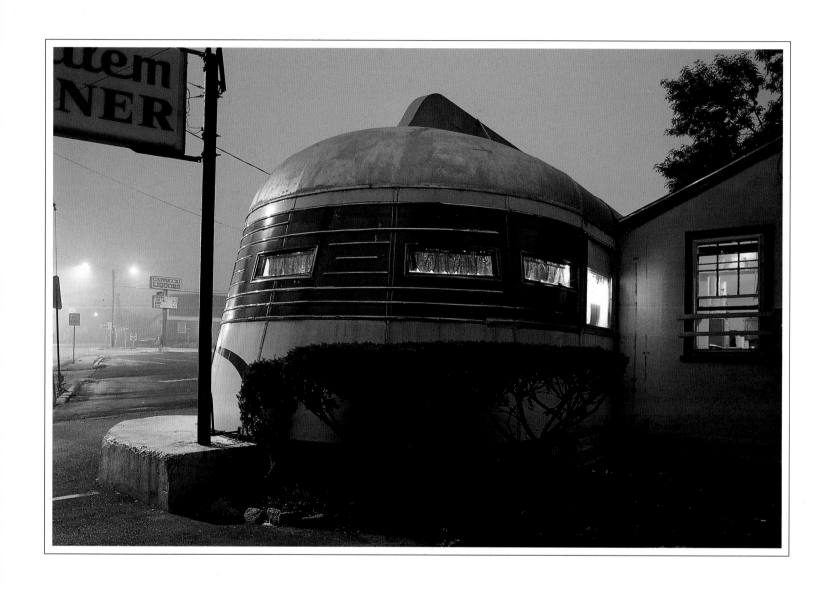

Salem Diner, Salem, Mass.

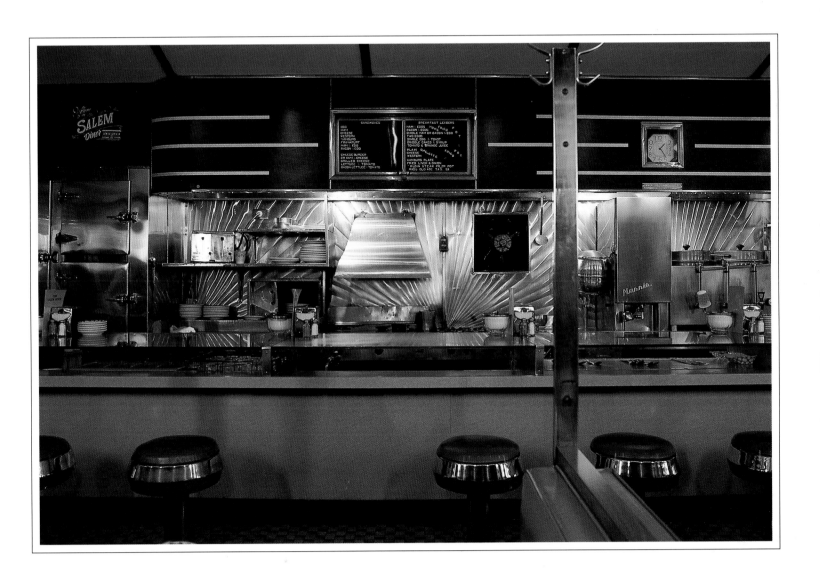

Salem Diner, Salem, Mass.

Midway Diner, Rutland, Vt. ⟩

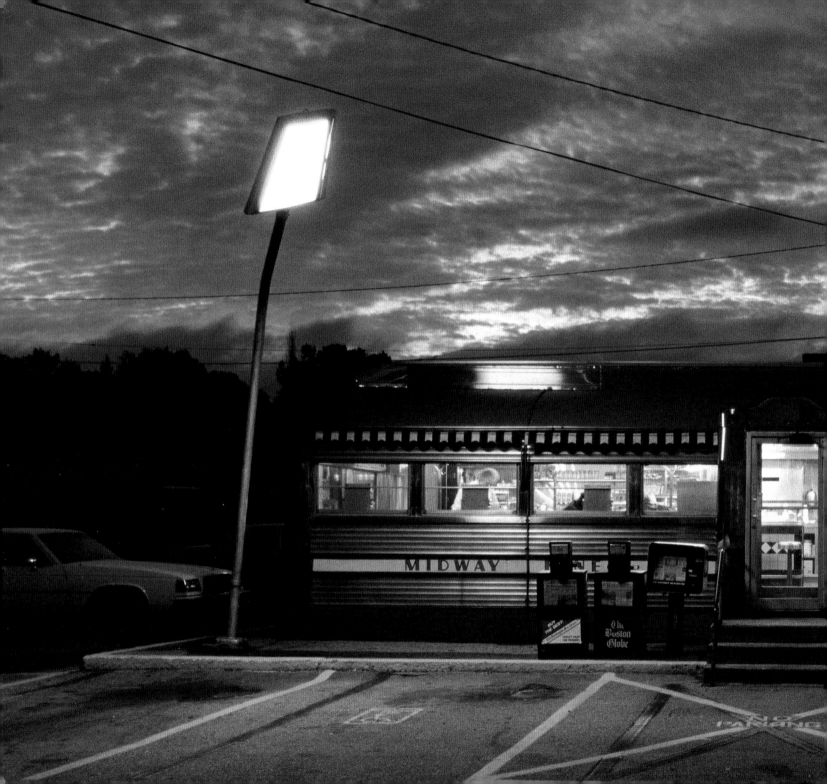

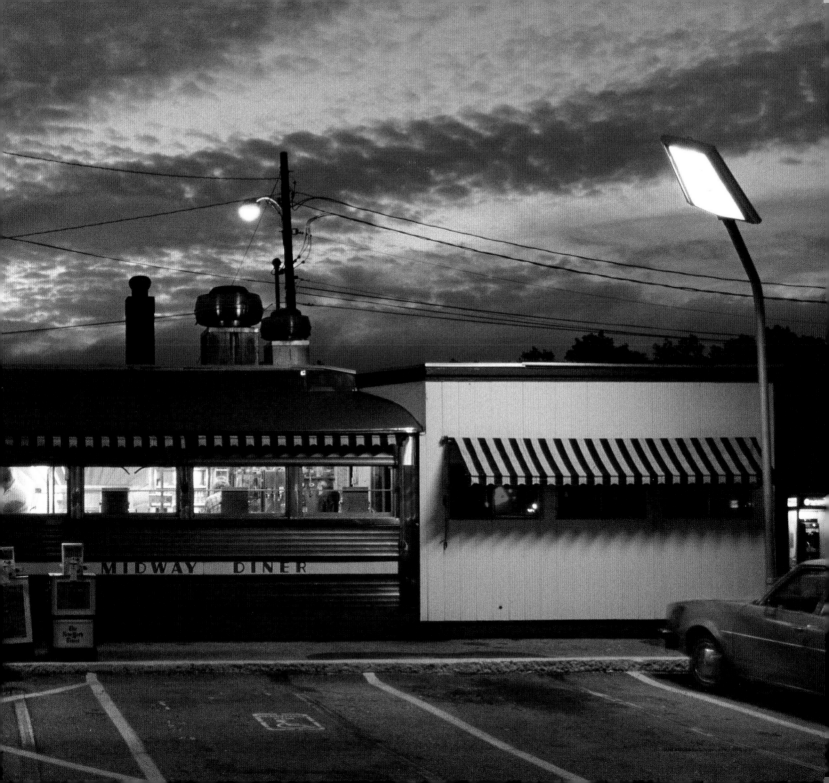

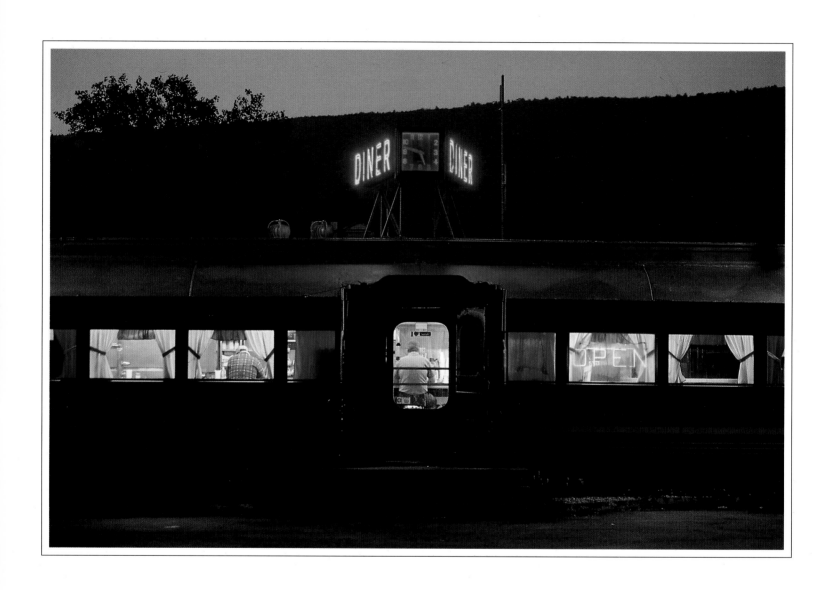

Charlotte's Diner, Ellenville, N.Y.

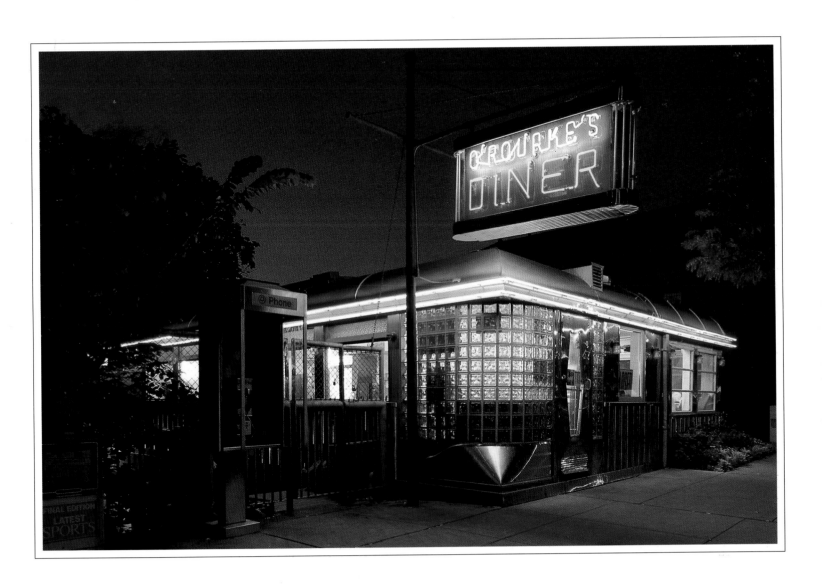

O'Rourke's Diner, Middletown, Conn.

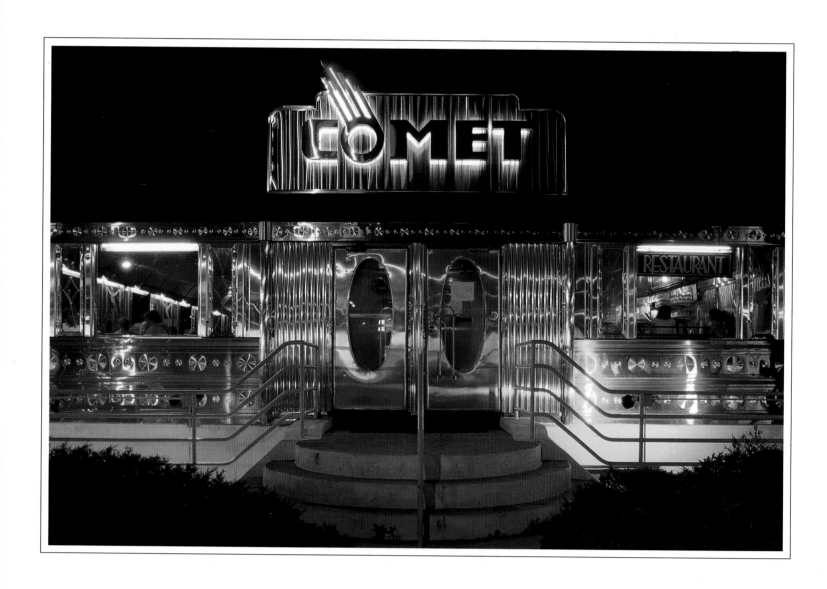

Comet Diner, Hartford, Conn.

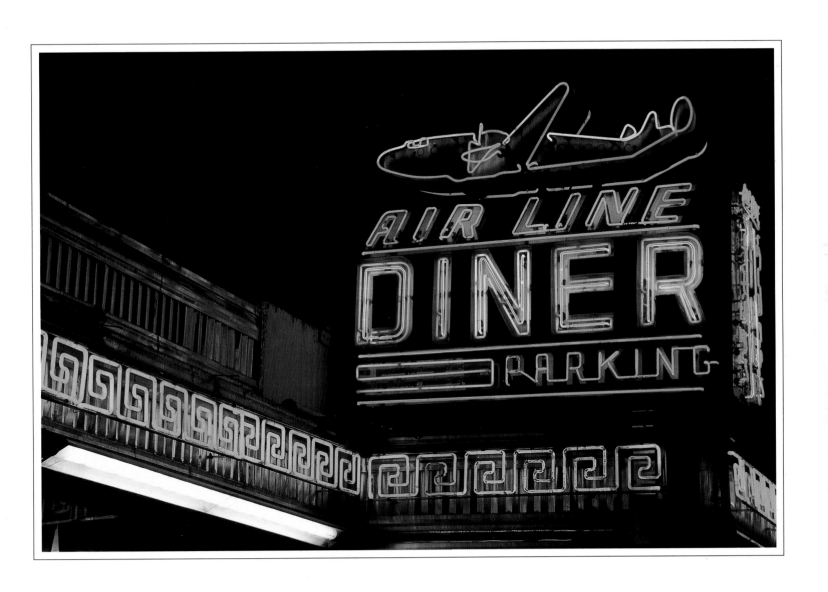

Airline Diner, New York, N.Y.

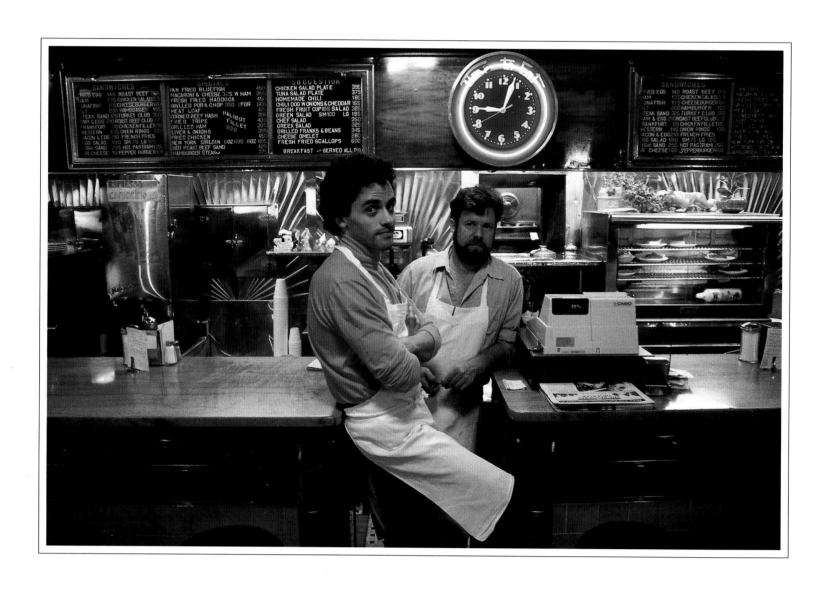

A1 Diner, Gardiner, Me.

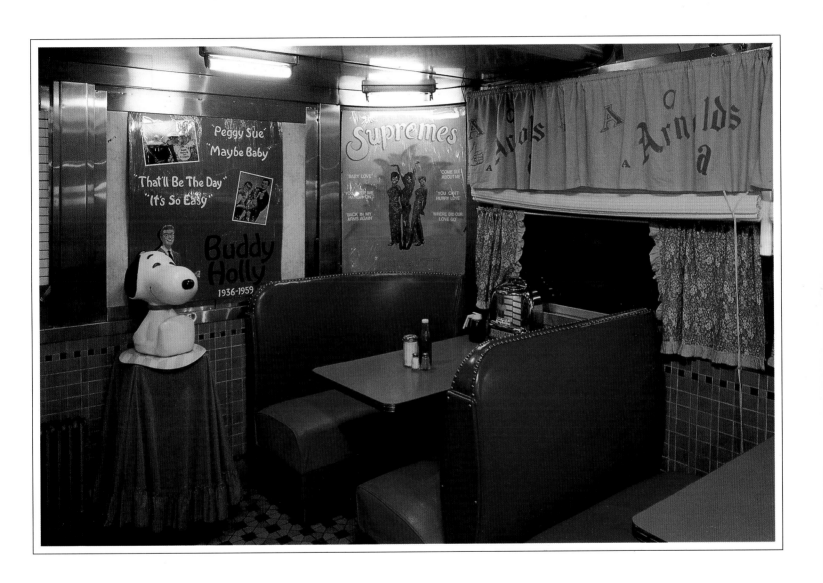

Arnold's Diner, Providence, R.I.

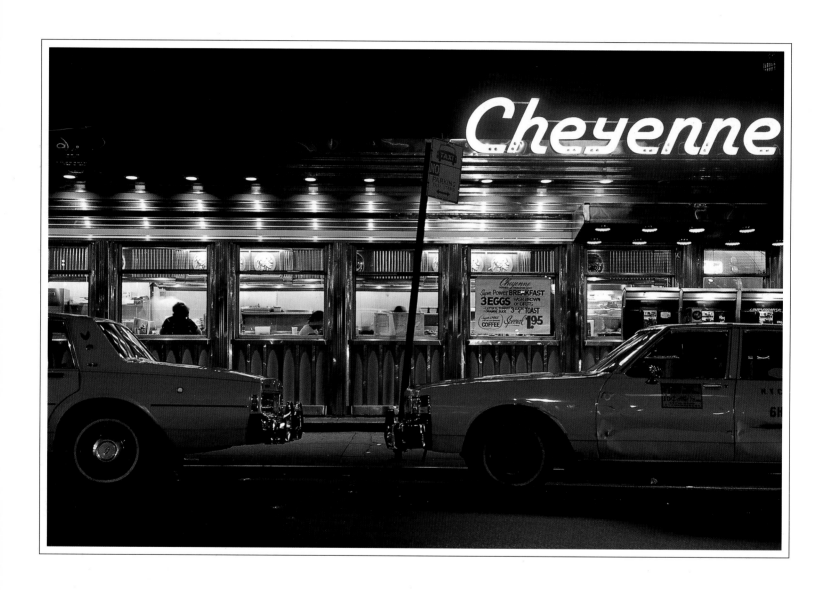

Cheyenne Diner, New York, N.Y.

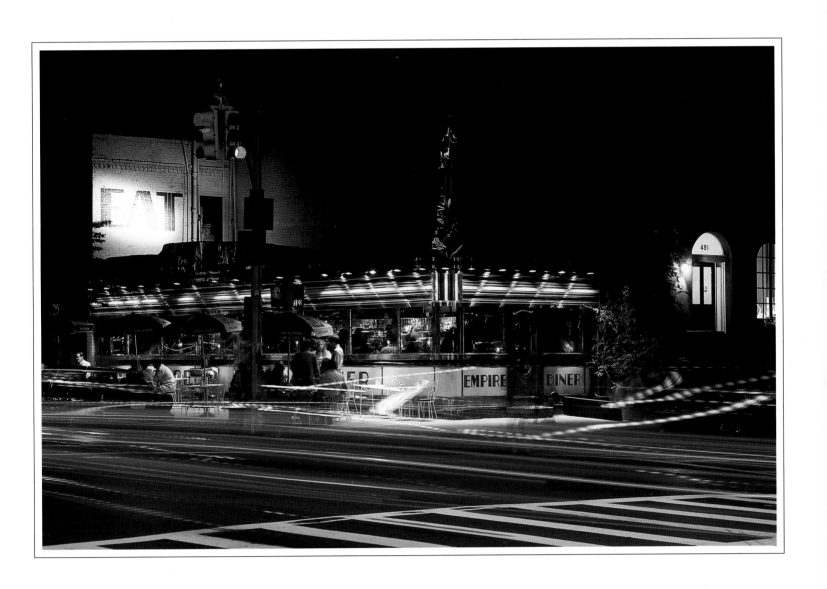

Empire Diner, New York, N.Y.

Fog City Diner, San Francisco, Calif. ⟩

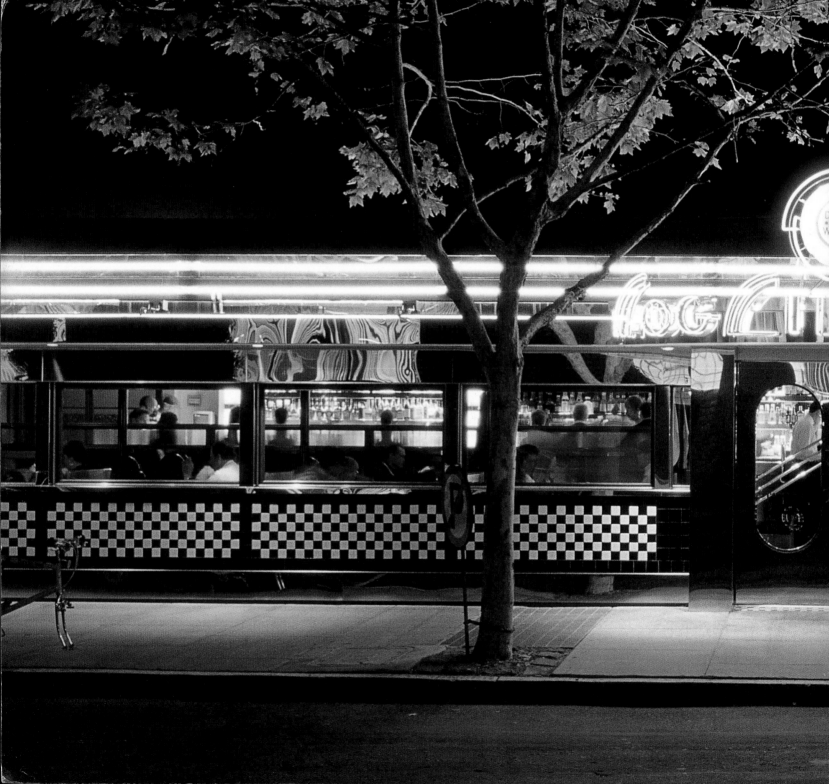

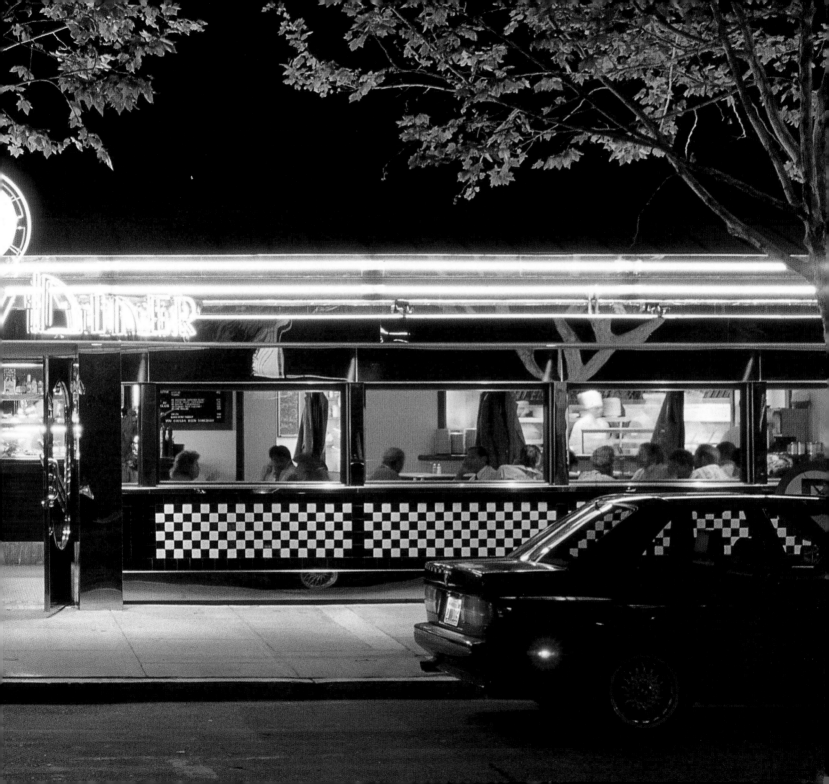

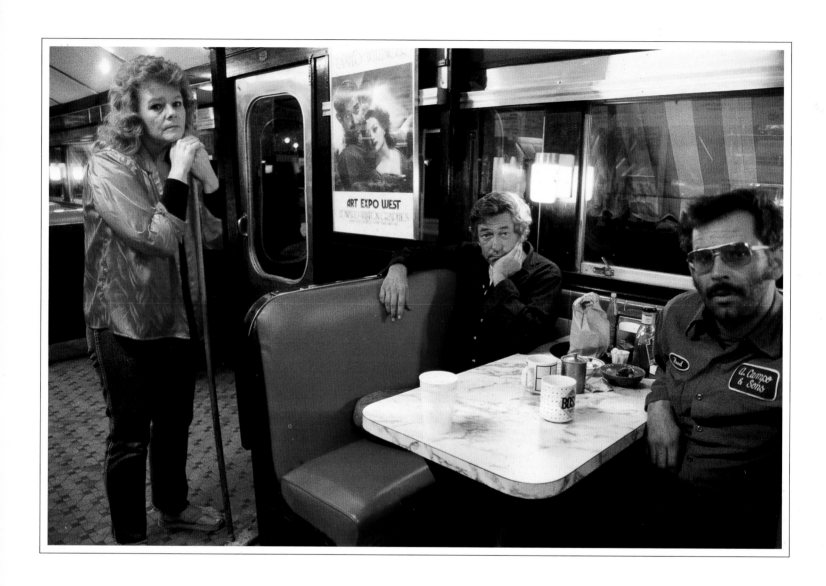

Roadside Diner, Wall, N.J.

Salem Diner, Salem, Mass.

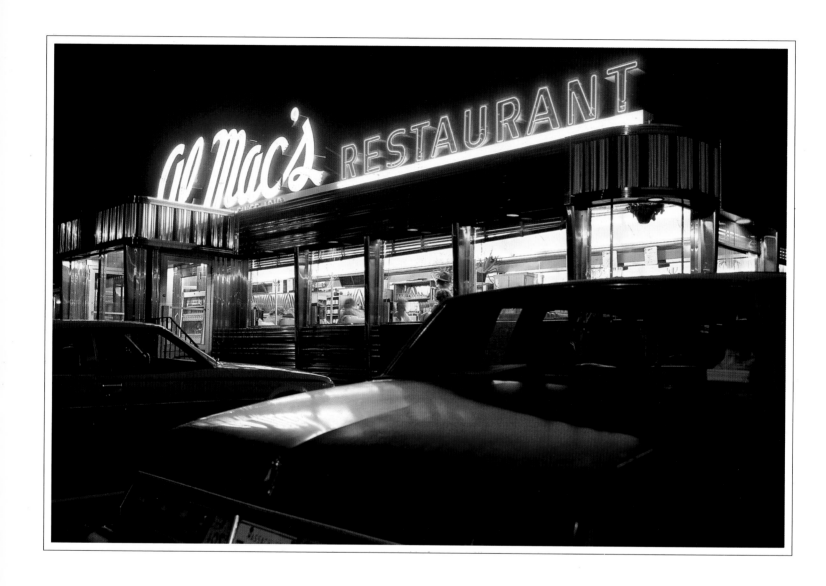

Al Mac's, Fall River, Mass.

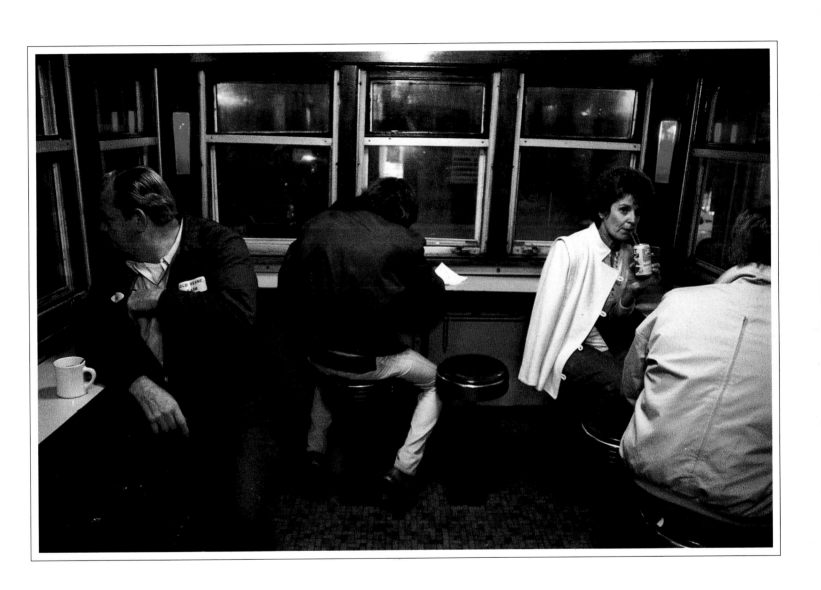

Gilley's Lunch Wagon, Portsmouth, N.H.

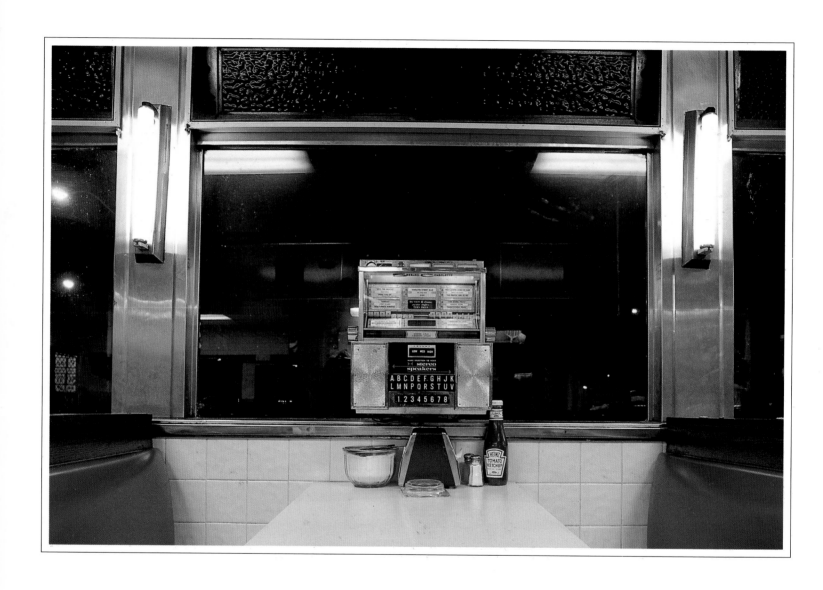

O'Rourke's Diner, Middletown, Conn.

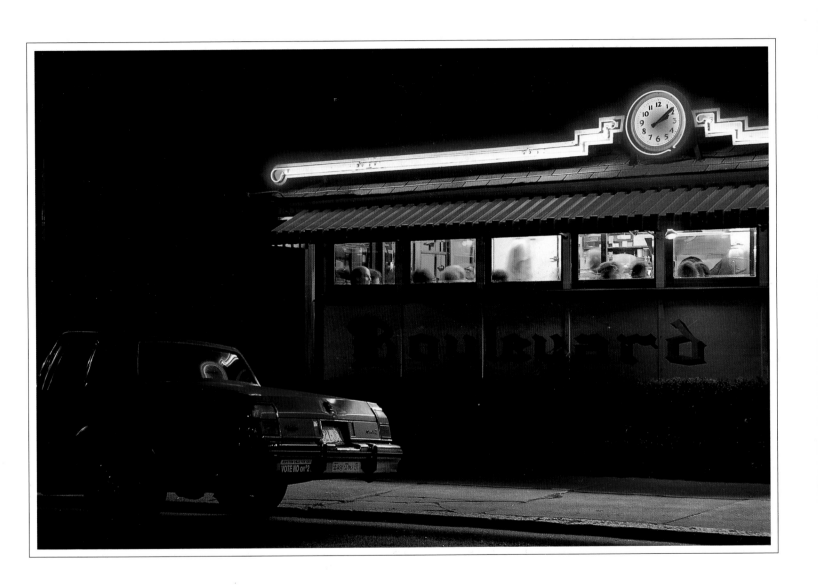

Boulevard Diner, Worcester, Mass.

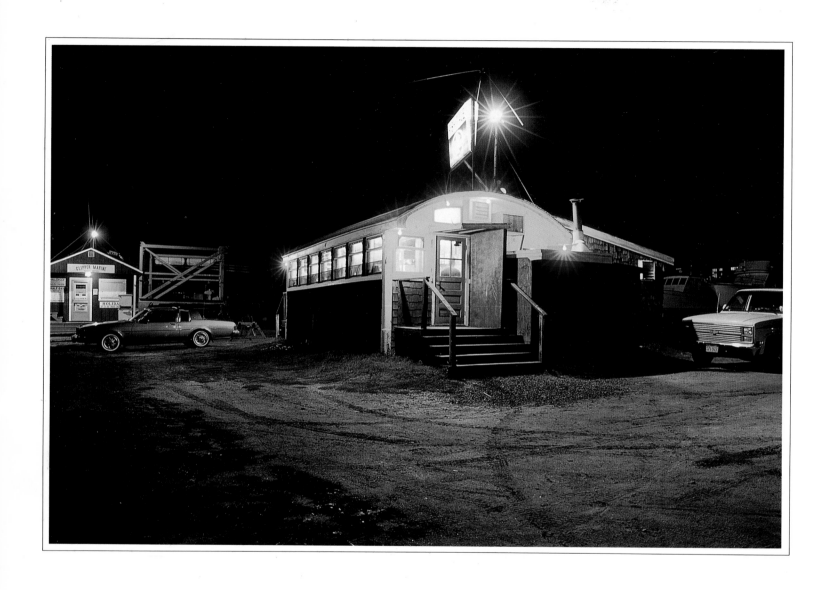

Fishtale Diner, Salisbury, Mass.